HAPPINESS
through conformity

CONFORMITY
through influence

INFLUENCE
through spin

•

 Wolf&Co.

•

At *Wolf&Co.* we're proud to say we're in the business of making people feel happy.

Happy to do as they're told. Happy to never question authority. And more than happy to swallow any old lie we tell them is the truth.

Now that makes us laugh!

Recently things have changed though. Social media has gone all grown up and propaganda has a brand new name – 'fake news'.

But don't be fooled. It's a bit like when a Peacock spreads its tail. Looks totally different with all them fancy feathers, but underneath it's the same old bird.

This new edition of Spinfluence is required reading as part of your training to become a Warden of Language & Falsities.

Good luck Young Cub. Control of the masses depends upon your continued vigilance.

ISBN 978-1-908211-64-4

A catalogue record for this book is available
from the British Library.

This edition published in Great Britain in 2018
First published in Great Britain in 2013
by Carpet Bombing Culture

www.carpetbombingculture.com
email: books@carpetbombingculture.co.uk
© Carpet Bombing Culture

Nick McFarlane 2013

The right of Nick McFarlane to be identified as
the author of this work has been asserted by him
in accordance with the Copyright, Designs and
Patents Act 1988.

The author,

Nicholas M^cFarlane

— *Presents* —

SPINFLUENCE

— THE —

HARDCORE
PROPAGANDA
MANUAL

FAKE NEWS
SPECIAL EDITION

— *to* —

I, the undersigned Young Cub agree, as part of
my indoctrination process, to read and study all
of the ten steps contained within this manual.

HOW TO CONTROL THE MASSES
USING SPINFLUENCE AND FAKE NEWS:

λ. ~~CONGRATULATIONS, BROTHERLING AND THE PLEDGE OF THE WOLF~~

~~Every single trigger~~ Brain and the Illusion of Power.

SPIN:

The technique in which language is used to propagate a biased idea or interpretation of events.

SPINFLUENCE:

The power and influence
that spin exerts over a person's
thoughts, feelings and behaviour.

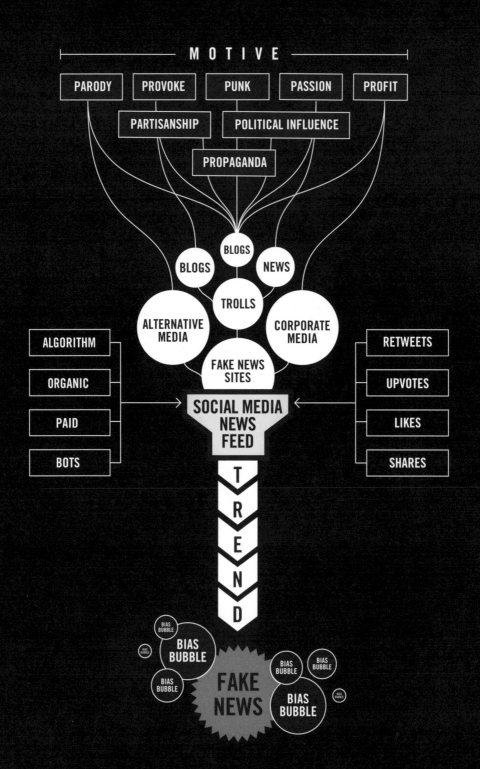

FAKE NEWS

Fake news is an insidious type of 'journalism' where stories are published, and then spread via social media, with the deliberate intent to deceive the public.

During the 2016 US Presidential election and 'Brexit' referendum, numerous fake news stories trended online – which according to some pundits, may have played a role in swaying the results.

Some say 'fake it 'til you make it', but we prefer to make it and then fake it.

Who's faking it?

Fake news can be created by literally anyone with a finger on the pulse of culture, a penchant for mischief, or a healthy desire to undermine democracy.

Bloggers, alt-media, establishment news, corporate media, fake sites, trolls, Macedonian teenagers... and of course even Donald Trump himself have all given fake news a spin at one time or another.

 Anthony Dimaggio, *Post-Fact Politics, counterpunch.org,* 06/12/16

"Empirical media studies have documented since the 1970s the overwhelming government dominance of the news. Government control of the news is uncontroversially labeled propaganda in dictatorships like North Korea and the old Soviet Union, but when journalists working for private media corporations willingly roll over for government interests, allowing them to monopolize newspapers and the airwaves in favor of their own agendas, we call it "objectivity.""

DECEPTION LEVEL

FABRICATED CONTENT 7
NEW CONTENT THAT IS 100% FALSE.

MANIPULATED CONTENT 6
GENUINE INFORMATION OR IMAGERY IS MANIPULATED.

IMPOSTER CONTENT 5
IMPERSONATION OF GENUINE SOURCES.

FALSE CONTEXT 4
GENUINE CONTENT IS SHARED WITH FALSE CONTEXTUAL INFORMATION.

MISLEADING CONTENT 3
MISLEADING USE OF INFORMATION TO FRAME AN ISSUE/INDIVIDUAL.

FALSE CONNECTION 2
HEADLINES, VISUALS OR CAPTIONS DON'T SUPPORT THE CONTENT.

SATIRE OR PARODY 1
NO INTENTION TO CAUSE HARM BUT POTENTIAL TO FOOL.

FAKE NEWS
ON

*Claire Wardle, First Draft News.

What the f@ke!?

Fake news has been identified as falling into seven broad categories.[*]

From reasonably harmless satire or parody, where the intent is to humour rather than to mislead.

Through to high-level deception, where the stories context or content has been manipulated or even completely fabricated.

Either way, the story must have enormous popular appeal.

[*]Claire Wardle, First Draft News.

 | **Chris Jeub,** *Fake News Is About Deception, chrisjeub.com,* **2017**

"Members of the media, some top of the journalist's field, are intentionally fabricating, modifying, and lying to their viewers. Sometimes their intent is to smear a public figure or politician, to shame them with their Fake News stories."

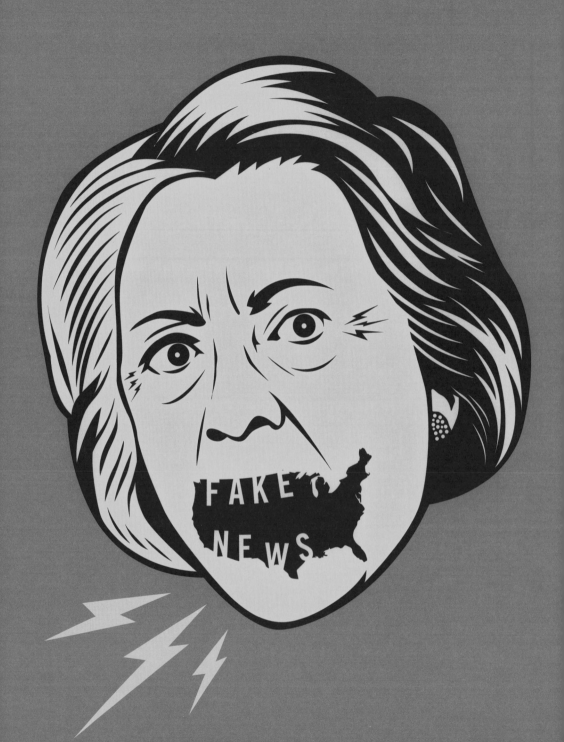

When did it explode?

According to Google Trends, the sudden spike in usage of the phrase 'fake news' occurred early October 2016, immediately after Wikileaks released the ▬▬▬▬ 'Podesta emails', in which evidence of political corruption within the Democratic National Party was discovered.

As a way of deflecting attention away from this highly damaging information, the leak was labeled fake news, and the rest is history.

 | Glenn Greenwald, *A Clinton Fan Manufactured Fake News...*, *theintercept.com*, 10/12/16

"When WikiLeaks was releasing emails from the John Podesta archive, Clinton campaign officials and their media spokespeople adopted a strategy of outright lying to the public, claiming — with no basis whatsoever — that the emails were doctored or fabricated and thus should be ignored."

PROPAGANDA
POLITICAL INFLUENCE
PARTISANSHIP

PROFIT
PUNK
PARODY

Why, oh why?

The ultimate motive behind fake news is to mislead – in order to benefit financially, or politically.

In an era of sensational clickbait advertising, pedaling fake news has proven to be hugely profitable.

Whilst in the political arena, firing out ~~███████████~~ fake news memes has clearly become the most devastating form of attack.

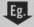 | Anthony Dimaggio, *Post-Fact Politics, counterpunch.org,* **06/12/16**

"The numerous frauds perpetrated on the mass public by officials themselves, who make use of the media to pedal what should be recognised as obvious propaganda. One could include on this list the entirety of Donald Trump's electoral campaign, which was a shameless fraud and a cruel hoax exacted on an increasingly politically illiterate and gullible mass public. Non-partisan fact checkers at Politifact concluded that, after examining hundreds of Trump's statements, just 15 percent could be classified as 'mostly true' or 'true.'"

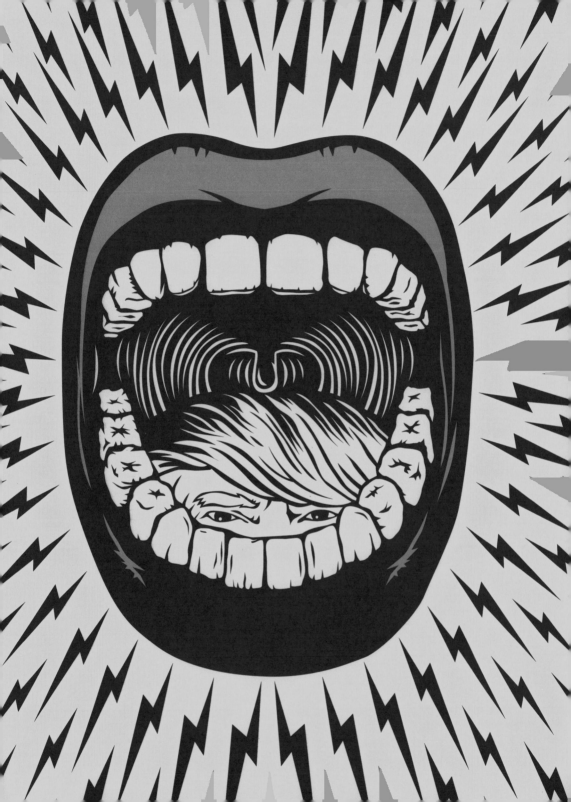

The art of the insult

At the heart of every fake news story, there is usually a vaguely plausible half-truth; one that the story's author suspects the largely gullible herd will happily swallow.

In politics, this half truth will originate from someone whose motive is to sway the narrative.

Trump has proven to be a master of the sound bite sized, tweet ready, fact-free verbal insult.

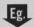 Daniel R. DePetris, *'A Divide-and-Conquer Strategy'*, *nationalinterest.com*, 2016

"Donald Trump is perhaps the most divisive figure ever in American politics. His language is often incendiary, and he has a knack for making racially-tinged comments that serve as a dog-whistle to his core supporters. But he won fair and square last night, and it's safe to say that Trump likely doesn't have any issues with the voting process he has derisively labeled as 'rigged.'"

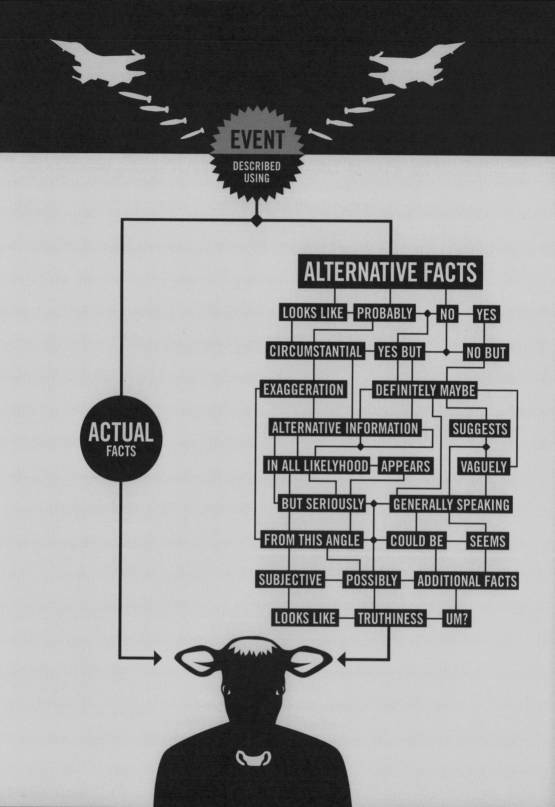

Alternative facts

As a means of justification, when accused of propagating fake news, the author will often claim to have simply been using alternative facts in the construction of their story.

In doing so, the perpetrator is able to deny lying and instead justify their message, through their subjective selection of information and interpretation of events.

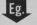 | wikipedia.org/alternativefacts, 2017

"'Alternative facts' is a phrase used by U.S. Counselor to the President Kellyanne Conway during a Meet the Press interview on January 22, 2017, in which she defended White House Press Secretary Sean Spicer's false statement about the attendance numbers of Donald Trump's inauguration as President of the United States. When pressed during the interview with Chuck Todd to explain why Spicer 'utter[ed] a provable falsehood', Conway stated that Spicer was giving 'alternative facts'. Todd responded, 'Look, alternative facts are not facts. They're falsehoods.'"

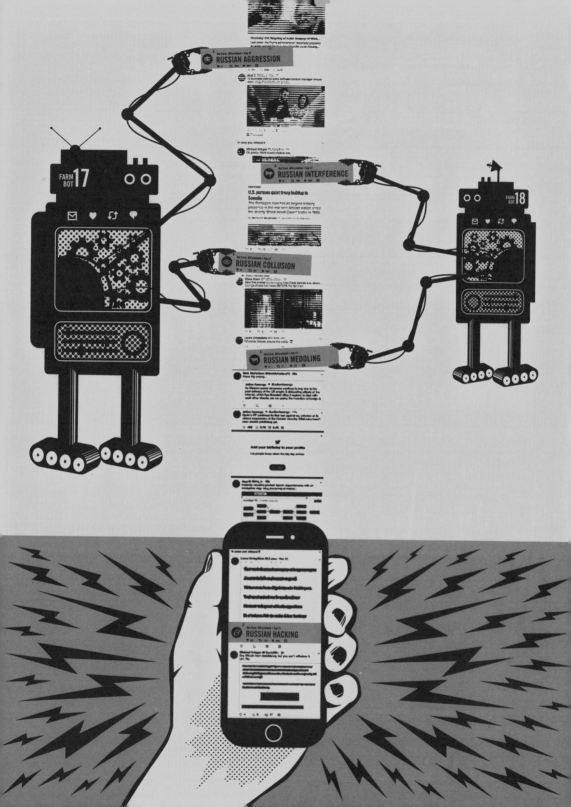

The news feed nexus

Crucial to the success of a fake news story is whether or not it gains traction and trends on social media news feeds around the world.

This can happen either organically, through genuine sharing of the story. Through paid-for promotion. Or by armies of ▓▓▓▓▓▓ bots, programmed to automatically upvote or share the story.

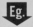 Claire Wardle, '*Fake news. It's complicated*', *First Draft News*, 2017

"Previous attempts to influence public opinion relied on 'one-to-many' broadcast technologies but, social networks allow 'atoms' of propaganda to be directly targeted at users who are more likely to accept and share a particular message. Once they inadvertently share a misleading or fabricated article, image, video or meme, the next person who sees it in their social feed probably trusts the original poster, and goes on to share it themselves. These 'atoms' then rocket through the information ecosystem at high speed powered by trusted peer-to-peer networks."

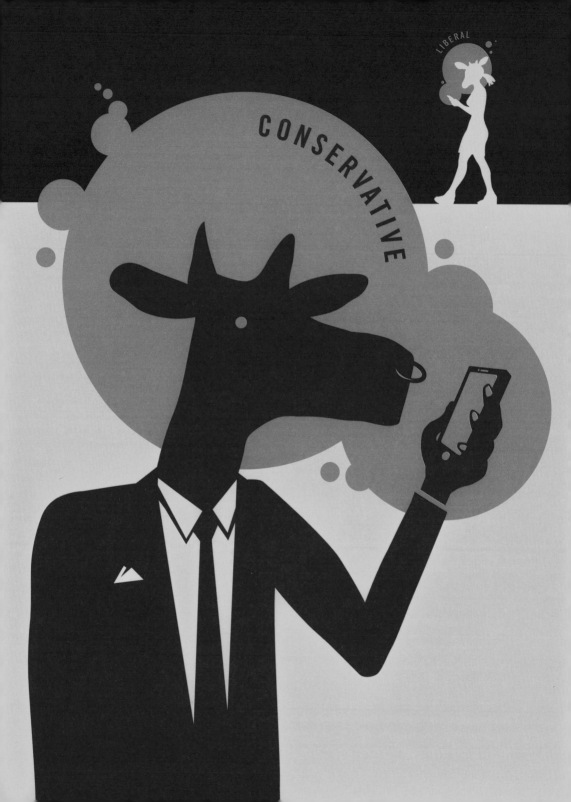

Bias Bubbles

A phenomenon which has developed in tandem with fake news, and in conjunction with social media sharing are bias bubbles.

Bias occurs when an individual becomes separated from information that disagrees with their viewpoints, effectively isolating them in their own cultural or ideological bubbles.

Eg. | Eli Pariser, *The Filter Bubble*, 2011

"The filter bubble tends to dramatically amplify confirmation bias—in a way, it's designed to. Consuming information that conforms to our ideas of the world is easy and pleasurable; consuming information that challenges us to think in new ways or question our assumptions is frustrating and difficult. This is why partisans of one political stripe tend not to consume the media of another. As a result, an information environment built on click signals will favor content that supports our existing notions about the world over content that challenges them."

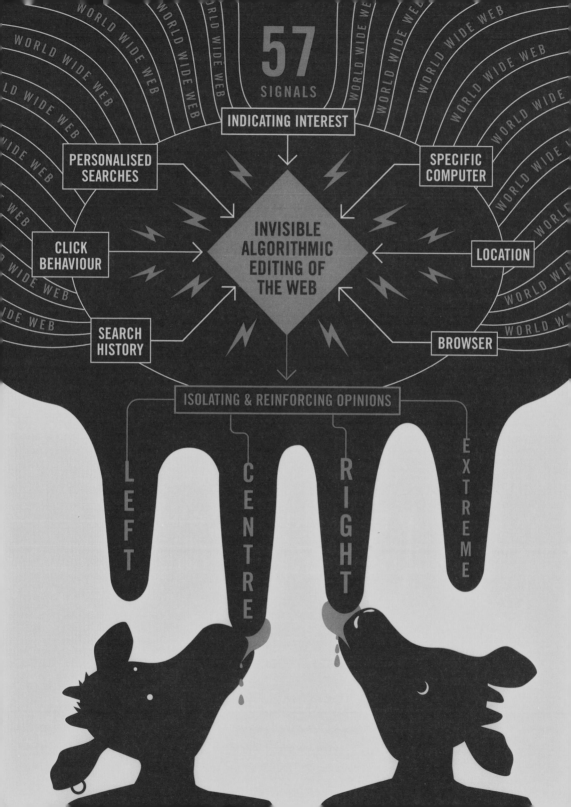

Algorithm filters

As the herd suckles the udder of the internet for information. They've little idea that their personal biases are being formed and isolated by information designed to reinforce their particular worldview.

This occurs due to the multitude of website algorithms selectively deciding what each person would like to see, and serving up more of the same.

 Eli Pariser, *The Future of the Internet, rooseveltinstitute.org,* 2010

"The important thing to remember with the Internet is that there are large companies that have an interest in controlling how information flows in it. They're very effective at lobbying Congress, and that pattern has locked down other communication media in the past. And it will happen again unless we do something about it."

OPINION

OPINION

INCOMPATIBLE
& REPELLENT

REPELLENT &
INCOMPATIBLE

OPINION

OPINION

Polarised populace

Through the constant ████████ indoctrination towards one way of thinking or the other. And the subsequent confirmation bias that takes place, entire communities, if not countries can easily have their opinions polarised to a point that they become totally repellent of anyone whose outlook on life differs from theirs.

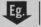 | Joachim Hagopian, *Divide and Conquer, globalresearch.ca,*23/10/15

"The retention of power by utilizing a deliberate strategy of causing those in subordinate positions to engage in conflicts with each other that weaken and keep them from any unified effort to remove the status quo force from power. This policy of maintaining control over subordinates or potential opponents by encouraging or causing dissent between them, thereby preventing them from uniting in opposition to pose any serious threat to the existing power structure is a very familiar story throughout history. It's an age old formula having multiple applications, most commonly used in the political arena but also in the military, sociological and economic realm as well.

Controlling the truth

Prior to the internet spawning a multitude of independent news providers, alternative points of view were rarely able to be seen or heard. As a result mainstream media assumed the role of moral guardians of the truth.

The proliferation of independent journalism now poses a threat to the status quo's ownership of truth, and the grip on power it provides.

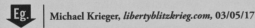 Michael Krieger, *libertyblitzkrieg.com,* 03/05/17

"The 2016 Presidential election was a gigantic wakeup call for the corporate press in the U.S. not so much because Hillary Clinton lost, but because it represented the end of mainstream media's ability to seamlessly force feed narratives down the throats of a gullible and pliant American public. The marketplace of ideas had been flooded by the internet and the people made a decision. The media wars came and went, and the corporate press lost, badly."

Weaponising fake news

'Fake News' has now become a convenient catch-all phrase, used to slander or discredit those who dare to challenge the official narrative or ▰▰▰▰▰ agenda.

For example, anyone who questions the US govt's self appointed right to "intervene" in sovereign nations such as Syria or Iraq will simply have the phrase 'fake news' hurled at them.

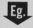 Hillary Kane, *Fake News and Weaponized Defamation, networks.h-net.org,* 09/08/17

"In some countries, dissemination of "false news" is a crime that is used to stifle dissent. This broad conception of fake news not only acts to repress evidence-based inquiry of government, scientists, and the press; but it also diminishes the power of populations to seek informed consensus on policies such as climate change, healthcare, race and gender equality, religious tolerance, national security and government corruption."

Heavy handed censorship

In the hysteria to tackle the scourge of fake news, the right to determine what is and isn't fake news has been largely handed over to a selection of corporate behemoths such as Facebook, Twitter and Google.

The problem is that legitimate and accurate reporting can be crushed through corporate agenda, or by the vested interest of *them*.

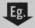 Glenn Greenwald, *A Clinton Fan Manufactured Fake News...*, *theintercept.com*, 10/12/16

"Complaints about Fake News are typically accompanied by calls for "solutions" that involve censorship and suppression, either by the government or tech giants such as Facebook. But until there is a clear definition of "Fake News," and until it's recognized that Fake News is being aggressively spread by the very people most loudly complaining about it, the dangers posed by these solutions will be at least as great as the problem itself."

THIS IS TRUE

THIS IS TRUE

THIS IS THE TRUTH

Post-truth politics

'Post-truth' is the political climate we now live in, where truth has become a subjective commodity, that can be bought and sold.

The powerful are able to propagate their perspective of the truth, through appeals to emotion. And by the repeated assertion of talking points, to which factual rebuttals are ignored, laughed at, or simply labeled as fake news.

 | George Orwell, *Nineteen Eighty Four*, 1949

"A world in which there in no verifiable truth, but only varied forms of propaganda, in which lies are repeated so often and so insistently that they become reality, where the audience is so exhausted and baffled by falsehoods that it no longer knows or cares where the truth lies."

Concept for illustration inspired by internet meme.

FAKE NEWS
SPECIAL EDITION

Know thy enemy

In this post-truth world, what is real and what isn't, becomes more and more difficult to discern; an ideal state to keep the herd bewildered and in line.

As part of our hardcore plan to control the masses it is required that we spy on some of the particular trouble-makers who have dared to peer behind the veil of secrecy and have discovered the truth. Their words should be considered highly dangerous, as they've hit a nerve, shedding light upon the dark shadows that *Wolf&Co.* use to keep *them* hidden.

As part of your training to become a *Warden Of Language & Falsities* you must familiarise yourself with their rabble rousing writings, so that you can help to identify and censor them in the future.

It is essential that their ideas spread no further if we are to maintain the blissful ignorance, comfortable corruption and glorious inequality upon which our illusion of power rests.

Julian Assange

Assange currently has political asylum whilst living under duress in the Ecuadorian Embassy in London. He is Editor in Chief of WikiLeaks, a highly troublesome organisation which specializes in the analysis and publication of large datasets of censored or otherwise restricted official materials involving war, spying and corruption. He is an advocate of transparency of government and should therefore be considered a threat.

Example of dangerous thinking:

Conspiracy as Governance
December 3, 2006

"To radically shift regime behavior we must think clearly and boldly for if we have learned anything, it is that regimes do not want to be changed. We must think beyond those who have gone before us and discover technological changes that embolden us with ways to act in which our forebears could not.

We must understand the key generative structure of bad governance.

We must develop a way of thinking about this structure that is strong enough to carry us through the mire of competing political moralities and into a position of clarity.

Most importantly, we must use these insights to inspire within us and others a course of ennobling and effective action to replace the structures that lead to bad governance with something better.

Conspiracy as governance in authoritarian regimes

Where details are known as to the inner workings of authoritarian regimes, we see conspiratorial interactions among the political elite, not merely for preferment or favor within the regime, but as the primary planning methodology behind maintaining or strengthening authoritarian power.

Authoritarian regimes create forces which oppose them by pushing against a people's will to truth, love and self-realization. Plans which assist authoritarian rule, once discovered, induce further resistance. Hence such schemes are concealed by successful authoritarian powers until resistance is futile or outweighed by the efficiencies of naked power. This collaborative secrecy, working to the detriment of a population, is enough to define their behavior as conspiratorial."

An authoritarian conspiracy that cannot think is powerless to preserve itself against the opponents it induces

When we look at an authoritarian conspiracy as a whole, we see a system of interacting organs, a beast with arteries and veins whose blood may be thickened and slowed until it falls, stupefied; unable to sufficiently comprehend and control the forces in its environment.

Later we will see how new technology and insights into the psychological motivations of conspirators can give us practical methods for preventing or reducing important communication between authoritarian conspirators, foment strong resistance to authoritarian planning and create powerful incentives for more humane forms of governance."

MAINTAIN SURVEILLANCE:

www.wikileaks.org
@wikileaks
@julianassange

Michael Krieger

A former Lehmans Brothers oil analyst who says "I started to educate myself about how the monetary and financial system functions and what I discovered disgusted me." He now writes a blog dedicated to decoding "issues of significant societal importance". His startling insights and clarity of thought make him highly dangerous.

<u>*Example of dangerous thinking:*</u>
The Most Dangerous Fake News of All is Peddled by the Corporate Media
June 27, 2017

"Fake news, propaganda and garbage information is everywhere and I'm not going to pretend otherwise. That being said, the key thing to understand is fake news from obscure websites you've never heard of is not what represents the real, global danger of rampant dishonest information. The real danger of fake news is the stuff that's consistently being vomited onto the pages of "respectable," billionaire-owned corporate media.

Obscure blogs and independent thinkers such as myself aren't influencing foreign policy, domestic policy or anything that really matters (look

around you). While alternative media did indeed play a monumental role in the election of Donald Trump, how much really changed when it comes to the true power centers?

Not much, not much at all. Goldman Sachs and Wall Street are more in control than ever before, and neocons and other assorted interventionists seem to be running foreign policy.

All of this reminds me of the famous saying, "if voting made any difference, they'd make it illegal." Indeed, the time has come for all of us to own up to the very real and present danger of corporate media, which seemingly exists to provide public relations for oligarchs and the foreign policy establishment. Not that this should be surprising, you'd have to be the most naive creature on earth to think newspapers owned by billionaires are going to tell the public the truth. Indeed, I made the following observation earlier today on Twitter.

Truth be told, it's way beyond bizarre, it's downright terrifying. Note that most major newspapers could barely catch their breath from demonizing Trump during his first three months, yet suddenly saw him as a heroic figure as soon as he lobbed a few bombs at Assad. This is like giving a puppy a treat for peeing on a wee wee pad. The corporate press is literally training Trump to wage as much imperial war as possible. It's crucial to understand that Trump, or any other administration really, can only do so much on the interventionist war front as the corporate press permits and pushes. Unfortunately, the corporate press is always pushing for war.

Today provided yet another example of how the "respectable" oligarch-owned press unquestionably repeats government propaganda when it comes to foreign policy. Two days after Seymour Hersh blew a hole in the fairytale account of Assad using chemical weapons in April, and merely a few hours after Sean Spicer started conditioning the public for more war with evidence-free claims that another chemical attack was imminent...

Which brings me to the main point. The major newspapers do not hold power to account. They aren't working for the public interest, and you can see the results all around us. With government, corporate oligarchs and the media entirely aligned against the best interests of the population at large, the situation looks very bleak. The imperial train wreck appears unstoppable."

MAINTAIN SURVEILLANCE:

www.libertyblitzkrieg.com
@LibertyBlitz

Chris Hedges

Chris Hedges is a Pulitzer Prize-winning journalist, New York Times bestselling author, former professor at Princeton University who's been arrested numerous times for activism.

He is of grave concern as he chose to follow his conscience and leave the NYT rather than bend to their editorial will and present a sanitised version of the Iraq War.

Example of dangerous thinking:

*RT America Torched in Witch Hunt '17
November 12, 2017

—

†Fight the Disease, Not the Symptoms
November 12, 2017

*"In one of the most horrendous blows to press freedom since the anti-communist witch hunts of the 1950s, the U.S. Department of Justice has forced the news broadcaster RT America to file under the Foreign Agents Registration Act (FARA).

The assault on RT America, on which I host the show "On Contact," has nothing to do with the dissemination of Russian propaganda. It is driven by RT America's decision to provide a platform to critics of American capitalism and imperialism, critics who lambast a system of government that can no

longer be called democratic. And it is accompanied by the installation of algorithms by Google, Facebook and Twitter that divert readers away from left-wing, progressive and anti-war websites, including Truthdig. The World Socialist Web Site has seen its search traffic from Google fall by 74 percent since April. Google, in a further blow, this month removed RT from its list of "preferred" channels on YouTube. Twitter has blocked all advertising by the channel."

† "The disease of globalized corporate capitalism has the same effects across the planet. It weakens or destroys democratic institutions, making them subservient to corporate and oligarchic power. It forces domestic governments to give up control over their economies, which operate under policies dictated by global corporations, banks, the World Trade Organization and the International Monetary Fund. It casts aside hundreds of millions of workers now classified as "redundant" or "surplus" labor. It disempowers underpaid and unprotected workers, many toiling in global sweatshops, keeping them cowed, anxious and compliant. It financializes the economy, creating predatory global institutions that extract money from individuals, institutions and states through punishing forms of debt peonage. It shuts down genuine debate on corporate-owned media platforms, especially in regard to vast income disparities and social inequality. And the destruction empowers proto-fascist movements and governments.

These proto-fascist forces discredit verifiable fact and history and replace them with myth. They peddle nostalgia for lost glory. They attack the spiritual bankruptcy of the modern, technocratic world. They are xenophobic. They champion the "virtues" of a hyper-masculinity and the warrior cult. They preach regeneration through violence. They rally around demagogues who absolve followers of moral choice and promise strength and protection. They marginalize and destroy all individuals and institutions, including schools, that make possible self-criticism, self-reflection and transcendence and that nurture empathy, especially for the demonized. This is why artists and intellectuals are ridiculed and silenced. This is why dissent is attacked as an act of treason."

MAINTAIN SURVEILLANCE:

www.truthdig.com/author/chris_hedges
@ChrisLynnHedges

John Wight

John Wight is an author and journalist who writes for Counter Punch. His essays cut to the bone as his acute observations jab straight to the heart of corruption and tyranny.

Counter Punch regularly annoys and irritates The Hidden Elite Minority as it provides a platform for those critical of neo-liberalism.

Example of dangerous thinking:

McCarthyism Redux: Attacks on the Russian Media
November 16, 2017

"In 2017 we are witnessing the rebirth of McCarthyism across the West in response to Russia's recovery from the demise of the Soviet Union and the failed attempt to turn the country into a wholly owned subsidiary of Washington via the imposition of free market economic shock treatment thereafter. In the process critical thinking and reason has been sacrificed on the altar of Pavlovian conditioning and unreason, resulting in the embrace of hysterical Russophobic nostrums by a liberal political and media class for whom Russia can only ever exist as a vanquished foe or a foe that needs to be vanquished.

When a think-tank with the impertinence of naming itself 'European Values' feels emboldened to compile and publish a 'hit list' of over 2000 contributors to RT, as it did recently, made up of politicians, former diplomats, journalists, and academics from across the West, the foundations of Western liberal democracy start to crack. And when the US Congress passes a bill to force RT America to register as a 'foreign agent' then we are talking war being waged not against Russian media per say, but the thousands of US citizens who work for Russian media and their right to ply their trade in the land of the free.

There is nothing that RT or Sputnik International does that other state-funded broadcasters – the BBC, Voice of America, and France24 et al. – are not doing when it comes to their operations overseas. All state-funded media engage in cultural outreach, and each proffers an analysis via the prism of their own cultural, ideological and national worldview.

But let us not be naïve. It would be a mistake to divorce this ongoing, ever-intensifying campaign to drive RT and Sputnik out of existence from the wider geopolitical struggle over the Washington-led unipolar status quo and the multipolar alternative demanded by Moscow's recovery and re-emergence as a global power, along with Beijing. In this regard, in the context of this geopolitical struggle, Russian media in the West is seen as low hanging fruit, an easy target by which to render Russia a bloody nose.

Does anyone really believe for a moment that if Russia had or did accept its place as a neo-satellite of Washington that this campaign against RT and Sputnik would be taking place? If both media channels were echo chambers of the Washington Consensus you can best believe they would be allowed to operate freely and without molestation, without their employees or contributors being traduced as 'Kremlin propagandists' or de facto 'Russian agents'.

The entire thing is a sham – a malicious and ideologically driven attempt to police the portals of news dissemination and analysis to the point where rigid acceptance and obeisance to the aforementioned Washington Consensus, responsible for upending the lives of millions at home and abroad over the years, is total."

MAINTAIN SURVEILLANCE:

counterpunch.org/author/ca4uvaye/
@JohnWight1

Max Blumenthal

Max Blumenthal is an award-winning journalist whose articles and video documentaries have appeared in The New York Times, The Los Angeles Times, The Daily Beast, The Nation and The Guardian.

But whilst he writes for the mainstream media, don't be fooled, as his specialty is subversion.

Example of dangerous thinking:
How 'Russian' Facebook Memes Expose the Brutal Realities of American Foreign Policy
October 23, 2017

"This month, American corporate media outlets have been whipped into a frenzy by revelations that a Russian internet troll farm purchased ads and established accounts on Facebook. According to the New York Times a "shadowy Russian company" supposedly "linked to" the Kremlin has spread "misinformation" on social media in order "to reshape American politics."

The ads allegedly contained messages promoting a wide array of hot button political issues, from police brutality and Islamophobia to gun rights. Some also contained images

of adorable puppies. Congressional investigators have alleged that the ad campaign evidenced the Kremlin's intention to "sow chaos" and "promote racial division," claims that have been faithfully reproduced in corporate outlets like the New York Times and the Washington Post.

An article in the Daily Beast took the narrative a step further, asserting that the ads and memes spread on supposedly Russian troll accounts on Facebook were actually "fake news"—meaning that their content was objectively false, and was designed to deceive Americans into turning against their government's otherwise benevolent foreign policy goals.

The article in question, "Russians Impersonated Real American Muslims to Stir Chaos on Facebook and Instagram," claimed that a moderately popular Facebook page called United Muslims of America was in fact an "imposter account" that was "traced back to the Russian government."

According to the Daily Beast's Spencer Ackerman, Ben Collins and Kevin Poulsen, an allegedly Russian group "stirred chaos" by sharing memes on Facebook, Twitter and Instagram. The reporters also claimed these dastardly memes took "a sharp detour into fake news."

While many of the memes highlighted by the Daily Beast were hyperbolic, as Facebook memes tend to be, their content was far from "fake news." In fact, they hammered on some of the most uncomfortable realities and inconvenient truths of American foreign policy, particularly the CIA's covert support for Islamist insurgents from Afghanistan to Syria and how this policy fueled the rise of Al Qaeda and ISIS.

Through whitewashing and outright denial of the well-documented history of U.S. covert operations in the Middle East, the Daily Beast's reporters engaged in the very thing they were accusing Russian trolls of spreading: propaganda and fake news. The false claims are examined in detail below, along with the painful historical realities that Ackerman and his co-authors aimed to obscure."

MAINTAIN SURVEILLANCE:

www.maxblumenthal.com
@MaxBlumenthal

Anthony DiMaggio

Anthony DiMaggio is an Assistant Professor of Political Science at Lehigh University and holds a PhD in political communication.

Whilst this may make him sound academic, in reality he is a one man wrecking ball, charging towards the structures of power with a demented glint of sanity in his eyes.

Example of dangerous thinking:

Post-Fact Politics: Reviewing the History of Fake News and Propaganda

6 December 2016

"I fear that something very important is getting lost in this narrow fixation on fake news. My point is simple: fake news is nothing new. We have long lived in a post-truth society, with political propaganda dominating the "mainstream" news media, and contributing to disinformation campaigns aimed at manipulating public opinion. Edward Herman and Noam Chomsky documented the propagandistic elements of the news media in detail in their seminal Manufacturing Consent (MC) nearly three decades ago.

The Bush administration's "embedding" of "mainstream" media journalists with U.S. military units in the 2003 Iraq war, which required that these reporters sign agreements conceding power to the military to screen and potentially censor news reports and information in advance of them being published or broadcast. No self-respecting independent journalist would go to bed with military planners, but that's precisely what happened in the invasion of Iraq.

The blatantly propagandistic pre-war coverage of the 2003 Iraq war, which repeated ad nausea fraudulent Bush administration claims that Iraq retained ties to al Qaeda terrorists, possessed large stockpiles of chemical and biological weapons, was near to developing nuclear weapons, and could effectively attack U.S. targets within 45 minutes after an order were given. None of these claims were remotely true, as is now universally recognized. Perhaps most disturbing of all were the numerous records and statements of weapons-proliferation and intelligence experts at the United Nations, International Atomic Energy Agency, and U.S. intelligence agencies, which disputed Bush's claims, but were consistently ignored in the run-up to war, in favor of administration propaganda. The Bush administration,

as has been shown in numerous reports, knowingly manipulated information to make the case for war, ignoring the evidence contradicting claims of a threat, and despite the reality that the administration was uncertain about the extent to which Iraq possessed weapons of mass destruction.

The obsession of U.S. officials and media with demonizing Iran, falsely claiming that irrefutable evidence exists of an Iranian nuclear "threat." U.S. intelligence agencies concluded that Iran stopped development in its nuclear weapons program in the early 2000s, and no evidence was ever presented during the IAEA's investigations in the 2000s and 2010s that Iran was enriching uranium to use in developing nuclear weapons. Still, the Bush and Obama administrations routinely stressed this false narrative. U.S. media outlets, learning nothing from the Iraq fiasco, uncritically repeated official propaganda claims, in contradiction to available intelligence."

MAINTAIN SURVEILLANCE:

www.counterpunch.org/author/anthony-dimaggio/

STEP 1: SPINFLUENCE

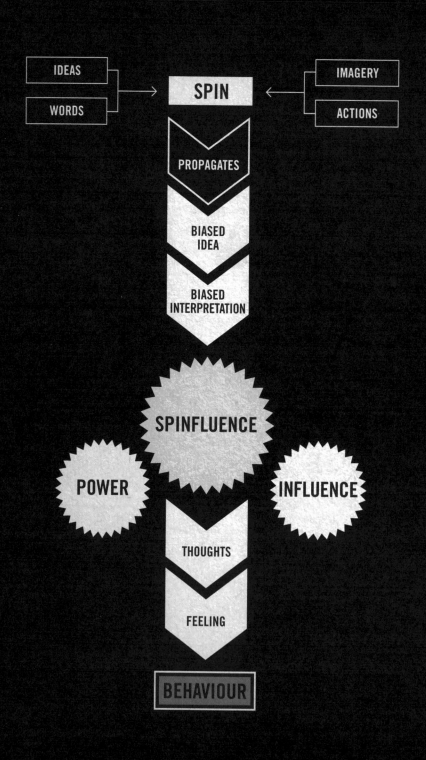

1.0 SPINFLUENCE

Spinfluence is most successful when the audience remains oblivious to the use of spin, believing instead that their behaviour is the result of their own independent thinking.

Language and semiotics are used to propagate a biased idea or interpretation of events.

Through this method, your audience is free to enjoy happiness through conformity.

Ideas are ammo

Ideas are the ammunition aimed at head and heart.

Simple ideas are often the most explosive as they connect with the widest range of people.

But what makes an idea truly deadly is how it's delivered.

Primarily through language & how things are labeled

 | Richard Stengel, *The Power of Ideas, Time Magazine*, 2008

"Ideas change the world. The power of a new idea is the engine that transforms the way we live and think. (Our country was founded on one.) It was almost 50 years ago that the philosopher Thomas Kuhn coined the term paradigm shift – the moment when our world view fundamentally changes because of a new idea, as when people understood that the sun does not revolve around the earth or that climate change is altering the way we would all have to live."

THE CONFLICT

eir own war

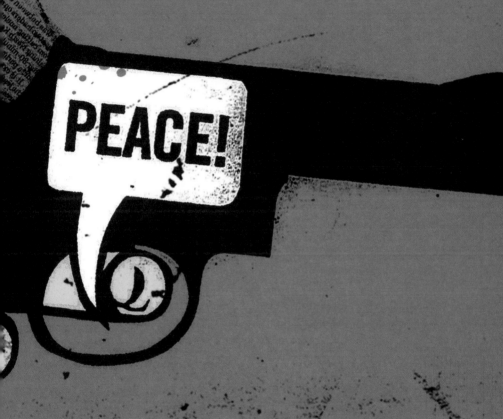

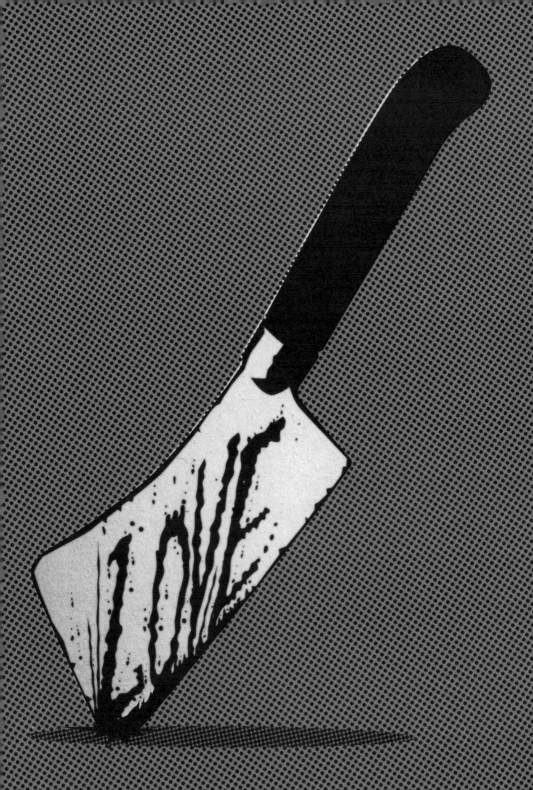

Words are weapons

Words are the most lethal weapons used in the battle for hearts and minds.

Sound bites and slogans are used to deliver persuasive messages and subversive ideas.

Eg. | Steven Poole, *Unspeak. Words are Weapons*, 2006

"These precision-engineered packages of language are launched by politicians and campaigners, and targeted at newspaper headlines and snazzy television graphics, where they land and dispense their payload of persuasion into the public consciousness."

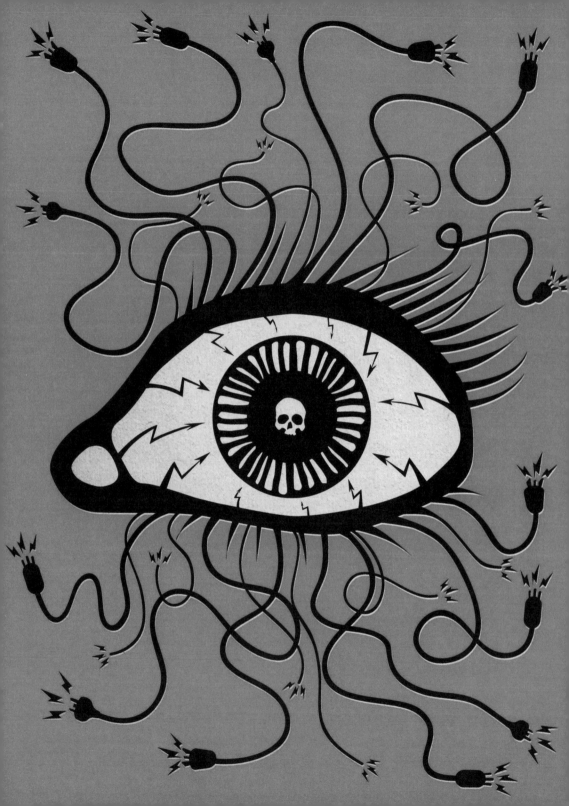

Imagery which electrifies

Images have the unparalleled ability to affect the mind and to leave a lasting impression.

A strong and graphic image has the power to both shock and seduce.

Visuals succeed where words fail, by condensing multiple layers of meaning into one symbolic image.

 Wolf&Co. *Distort-optics Dept, 1987*

"Huynh Cong Ut's iconic image taken during the Vietnam War of fleeing children, focusing on a nude girl whose clothes had been melted off by a napalm bomb, in one instant, dramatically affected the world's perception of the Vietnam conflict."

Actions cause impact

Action is the embodiment of an idea or belief.

Action gives significance to words and imagery.

It makes real what would otherwise be only rhetorical, visual or wishful.

Sometimes the flames need to be real for us to fan them properly.

Eg. | Wolf&Co. *Vexation Dept,* 1982

"The symbolic fire at the Reichstag (German Parliament) allowed Hitler to speed up and consolidate the Nazi Party's authority. By interpreting it as a Communist arson attack, a decree was passed which suspended many civil liberties such as freedom of the press. This helped in establishing the dictatorship and one-party Nazi state in Germany."

Propaganda hammers the message

Propaganda is the tool used to turn ideas, words, images and actions into persuasive and influential messages.

The basic materials with which propaganda works are:

- Rhetorical devices
- Influential imagery
- Symbolic action

Eg. | Noam Chomsky, *Media Control*, 1991

"Propaganda is to a democracy what the bludgeon is to a totalitarian state."

The battle for hearts and minds

The mental and emotional territory must be conquered if control of the masses is to be achieved. ▆▆▆▆▆▆▆

Propaganda is used not only to attack and seduce the senses but to also build a fortress around weak arguments.

Eg. | **Robert Greene,** *The Concise 33 Strategies of War,* **2006**

"Communication is a kind of war, its field of battle the resistant and defensive minds of the people you want to influence. The goal is to advance, to penetrate their defences and occupy their minds..."

STEP 2: PROPAGANDA

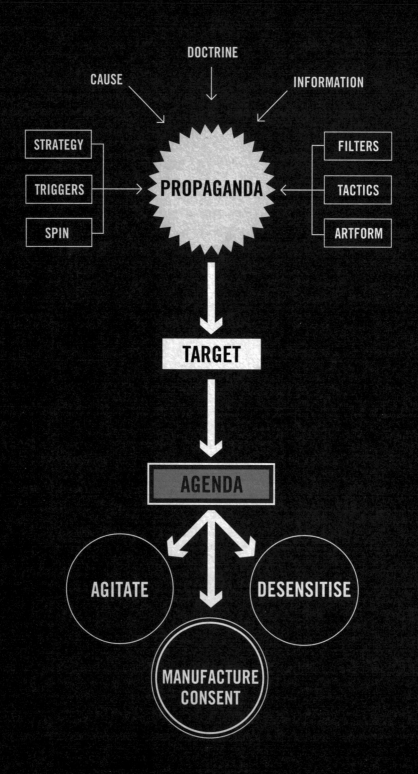

2.0 PROPAGANDA

Integral to spinfluence is propaganda.

Propaganda is the deliberate, systematic attempt to shape perceptions, manipulate cognitions and direct behaviour to achieve a response that furthers the desired intent of the *wolf*.

This chapter examines the who, what, when, where, why and how of propaganda.

T.H.E.M.

INSTITUTIONS

W.O.L.F. OPERATIVES

THE MASSES

THE HERD

Who?

Propaganda involves communication aimed at the masses by an elite minority who's hidden agenda is to control the herd.

As a propaganda agency, it is our task to keep *them* protected at the top of the pyramid, from the unruly and bewildered herd beneath.

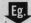 **Eg.** | Dan Gilmor, *The Guardian*. 23/11/11

"If we know anything about the recent income and accumulated assets of the now notorious 1%, it is that much of this wealth, by any rational standard, is undeserved. This applies especially to the Wall Street bankers who looted the global economy with sleazy tactics and, sadly, also with impunity."

What?

Put ideas in their head by hitting the heart...

Propaganda is characterised by its selective presentation of language and falsities in order to encourage a specific way of thinking.

It's purpose is to communicate a biased agenda with loaded messages intended to produce an emotional, rather than rational response.

Eg. | Edward Bernays, *Propaganda*, 1928

"Modern propaganda is a consistent, enduring effort to create or shape events to influence the relations of the public to an enterprise, idea or group. [It involves the] practice of creating circumstances and for creating pictures in the minds of millions of persons."

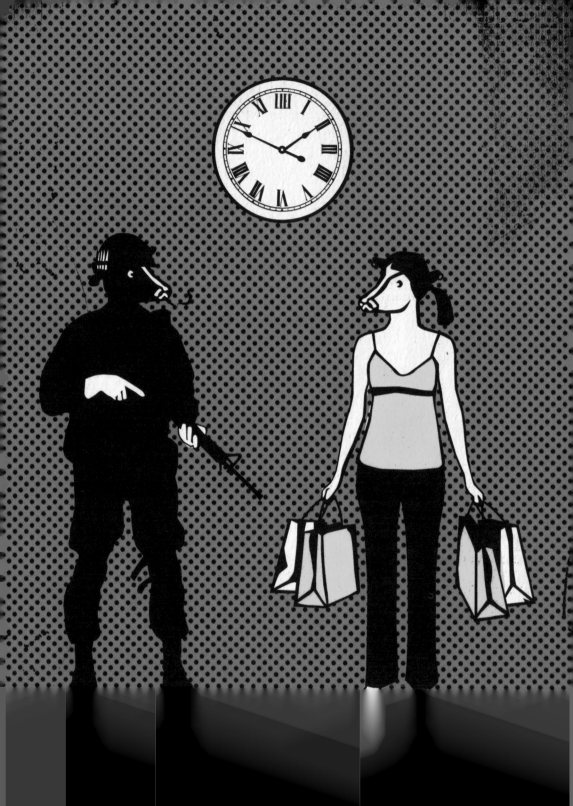

When?

Propaganda is used during both times of war and peace.

In wartime, it is used to galvanise the public behind the government's participation in the conflict.

During times of peace, it is used to maintain the public's docile happiness, primarily through the encouragement of cyclic consumer behaviour.

 Alec Carey *(Psychologist)*, 1995

"The twentieth century has been characterized by three developments of great political importance: the growth of democracy, the growth of corporate power, and the growth of corporate propaganda as a means of protecting corporate power against democracy."

Where?

Or it is used with violence. Carrot AND stick.

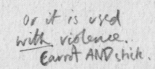

Propaganda is used globally in societies where overt physical force is no longer permitted.

Propaganda has become the preferred tool for use in public opinion management.

Wherever a small minority of people seek to rule the larger majority, you will find it to be in use.

 | Jacques Ellul, French philosopher. 1912–1994.

"The orchestration of press, radio and television to create a continuous, lasting and total environment renders the influence of propaganda virtually unnoticed precisely because it creates a constant environment."

THE BEWILDERED HERD

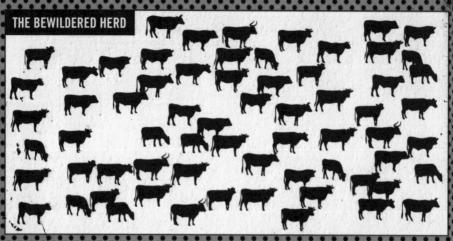

SPINFLUENCE

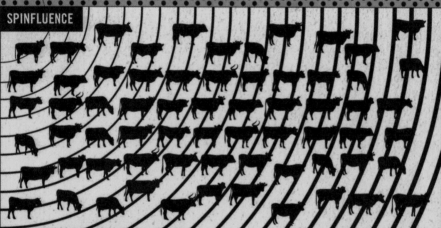

INFLUENCED BEHAVIOUR PATTERN

PROPAGANDA 2.5

Why?

The primary objective of all good propaganda is to achieve ▮▮▮▮▮▮▮▮▮▮ hrough Spinfluence.

By influencing behavioural patterns *they* can control and consolidate power over the masses. With the herd standing in line, enjoying docile content-ment, *they* are able to pillage and plunder at will.

←— From disorder to order. Controlled by spin —→

Eg. | Edward S. Herman & Noam Chomsky, *Manufacturing Consent,* 1988

"The mass media serve as a system for communicating messages and symbols to the general populace. It is their function to amuse, entertain, and inform, and to inculcate individuals with the values, beliefs, and codes of behaviour that will integrate them into the institutional structures of the larger society. In a world of concentrated wealth and major conflicts of class interest, to fulfil this role requires systematic propaganda."

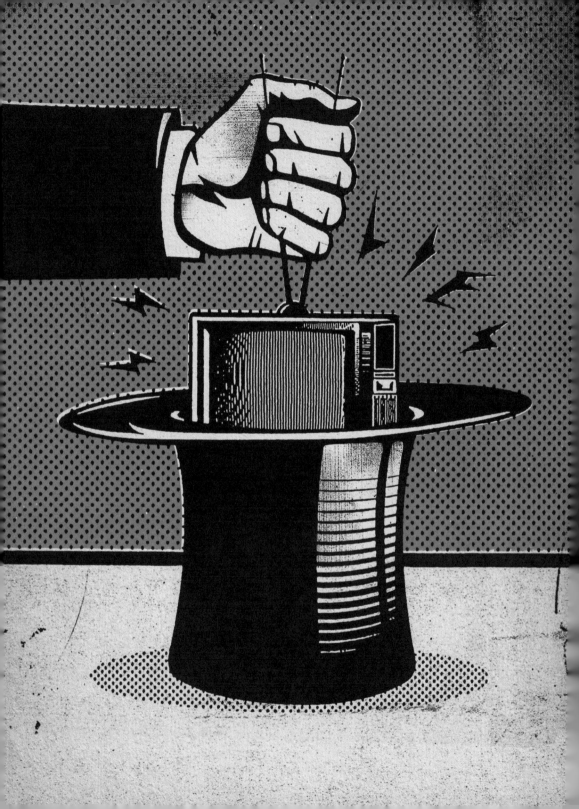

How?

To hide or to spin? That is the question. Censorship may be an effective method of thought control, but it is the ability to distort the truth which requires greater skill.

Through the manipulation and exploitation of lingual and visual ambiguities the conjurer is able to pull falsities out of fact, as if by magic

Eg. | *Sourcewatch.com,* 2011

"According to a recent study by the US Union of Concerned Scientists, [ExxonMobil] has spent more than $19 million to promote skepticism about global warming, funding think tanks, publications and web sites that are not peer reviewed by the scientific community."

STEP 3: THE HERD

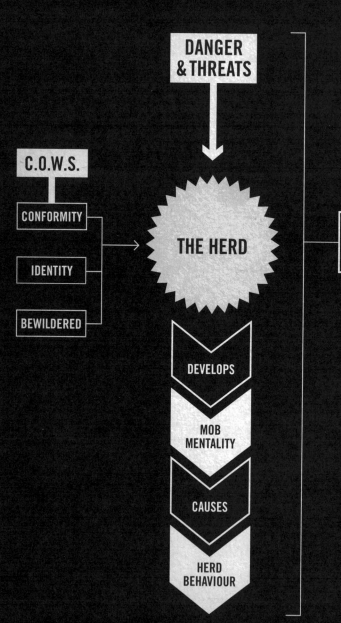

3.0 *THE HERD*

As with other species in the animal kingdom, when confronted with danger, people will retreat within the protection of a group.

Without leadership, this group has the potential to act in a bewildered manner – allowing for mob mentality to arise.

The *wolf* will purposely aim to provoke this type of behaviour.

*In this way the **wolf** can harness not just one **cow**, but the herd.*

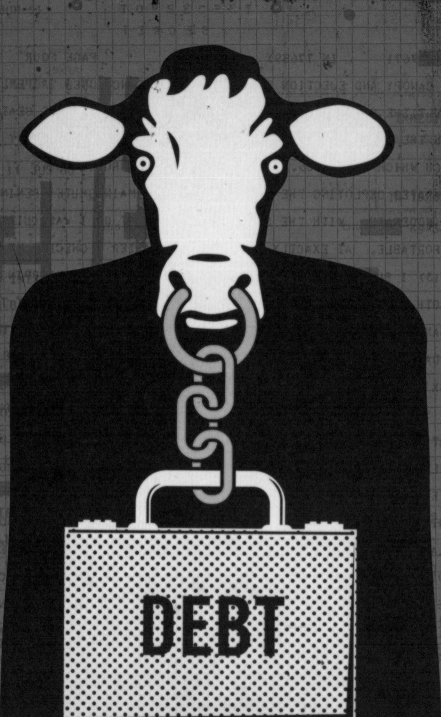

C.O.W.S.

Corporation Owned Wage Slaves: People who, straddled with debt are forced into a continuous cycle of long hours and servitude to their corporate masters.

In this position, *cows*[*] rarely challenge authority, instead focusing on their own ▓▓▓▓▓▓▓ financial hardships.

[*]Corporation Owned Wage Slaves will henceforth be referred to simply as *cows*.

Eg. | Peter Joseph. *Zeitgeist: Addendum, 2008*

"Money is created out of debt. And what do people do when they are in debt? They submit to employment to pay it off. It is the fear of losing assets, coupled with the perpetual debt and inflation inherent in the [economic] system... that keeps the wage slave in line. Running on a hampster wheel with millions of others, in effect powering an empire which truly benefits only the elite at the top of the pyramid."

The W.O.L.F.

It is the responsibility of the Warden Of Language & Falsities[*] to ensure our version of the truth is always the most persuasive.

The *wolf* will combine cunning and stealth to frighten not just a few *cows* but indeed the broad masses of the herd.

[*]A Warden Of Language & Falsities will henceforth be referred to simply as a *wolf*.

Eg. | **Joseph Goebbels (Reich Minister of Propaganda), 1928**

"Success is the important thing. Propaganda is not a matter for average minds, but rather a matter for practitioners. It is not supposed to be lovely or theoretically correct... The point of a political speech is to persuade people of what we think right... Propaganda should be popular, not intellectually pleasing."

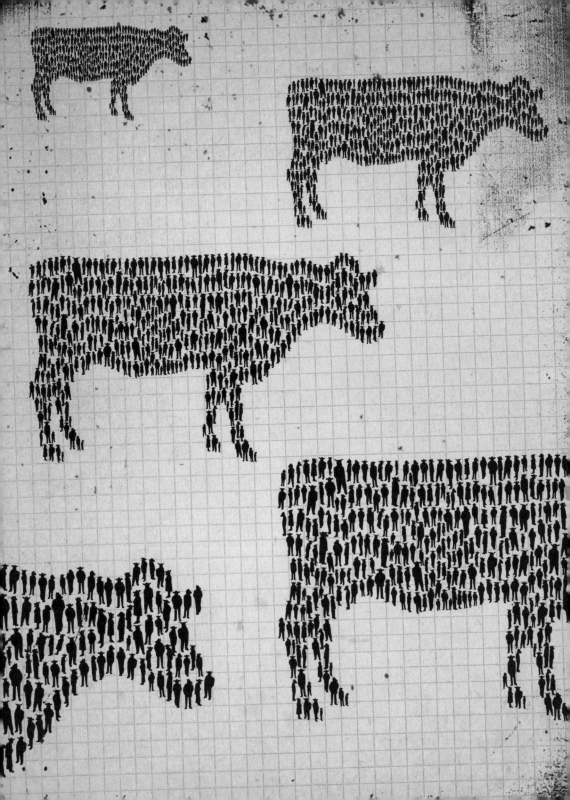

Herd behaviour

The phenomenon where groups of *cows* act in the same ~~way~~ way at the same time.

By adopting an indistinct profile from his peers, or by mimicking those around, the individual is able to minimise his exposure to risk.

This is how group parameters become established. People instinctively know which boundaries not to cross

Eg. | Dan Gardner, *Risk. The science and politics of Fear*, 2009

"From an evolutionary perspective, the human tendency to conform is not so strange. Individual survival depended on the group working together and cooperation is much more likely if people share a desire to agree. A band of doubters, dissenters, and proud nonconformists would not do so well hunting and gathering on the plains of Africa."

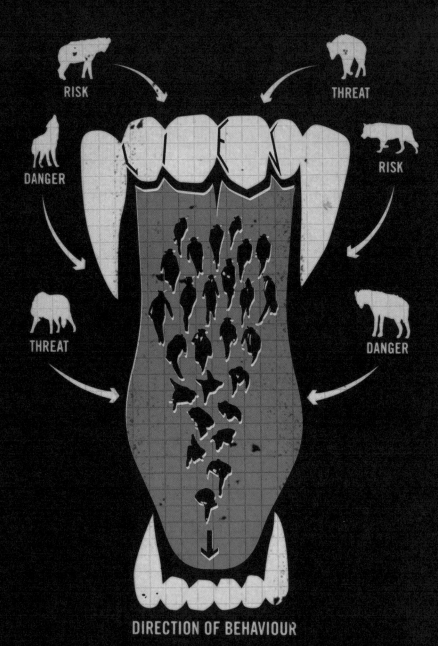

RISK

THREAT

DANGER

RISK

THREAT

DANGER

DIRECTION OF BEHAVIOUR

Danger and threats

Danger and threats to an individual can be of a physical or emotional nature.

In a potentially threatening situation *cows* will invariably react with a primal fight or flight response.

'Safety in numbers' as a strategy allows both the group and the individuals to preserve their security and minimise risk.

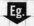 | Daniel Goleman, *Emotional Intelligence*, 1996

"Given the roots of anger in the fight wing of the fight-or-flight response, it is no surprise... that a universal trigger for anger is the sense of being endangered. Endangerment can be signalled not just by an outright physical threat but also, as is more often the case, by a symbolic threat to self-esteem or dignity: being treated unjustly or rudely, being insulted or demeaned, being frustrated in pursuit of an important goal."

Conformity

Conformity to the group helps maintain both safety and status.

Non-conformists may be seen as a liability and, left outside the group, they are forced to fend for themselves.

 Eg. | Michael Crichton, *The Lost World*, 1995

"The characteristic human trait is not awareness but conformity, and the characteristic result is religious warfare. Other animals fight for territory or food; but, uniquely in the animal kingdom, human beings fight for their 'beliefs'. The reason is that 'beliefs' guide behavior, which has evolutionary importance among human beings."

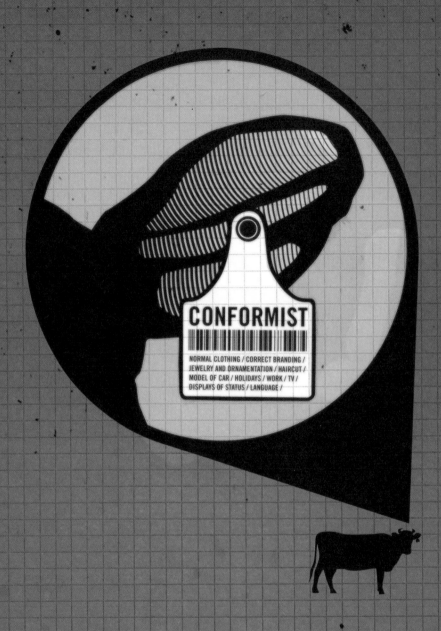

Herd identity

A herd's identity develops through its individuals' combined adherence to an ideology.

By acknowledging and displaying relevant symbols of conformity, the individual can move closer to the centre of group acceptance.

In turn, this self-serving behaviour reinforces the herd's identity.

Eg. | Neil Boorman, *Bonfire of the Brands,* 2007

"Teenagers use the symbolism of their favourite brands during the construction of their identity, gaining a sense of belonging when they use the same brands as those in their peer group. Mobile phones in particular are an important mark of acceptance within social groups, each using different covers, ringtones and glue-on jewelry to express their individuality."

THE HERD 3.7

The bewildered herd

Lacking confidence and in a state of anxiety, the herd is prone to acting in an erratic and unpredictable manner as the *cows* put their immediate concerns ahead of their long term and collective well-being.

The bewildered herd is a phrase coined by Walter Lipman.

Eg. | Noam Chomsky, *Media Control*, 1991

"We have to tame the bewildered herd, not allow the bewildered herd to rage and trample and destroy things. It's pretty much the same logic that says that it would be improper to let a three-year-old run across the street. You don't give the three-year-old that kind of freedom because the three-year-old doesn't know how to handle that freedom. Correspondingly, you don't allow the bewildered herd to become participant in [democracy]. They'll just cause trouble."

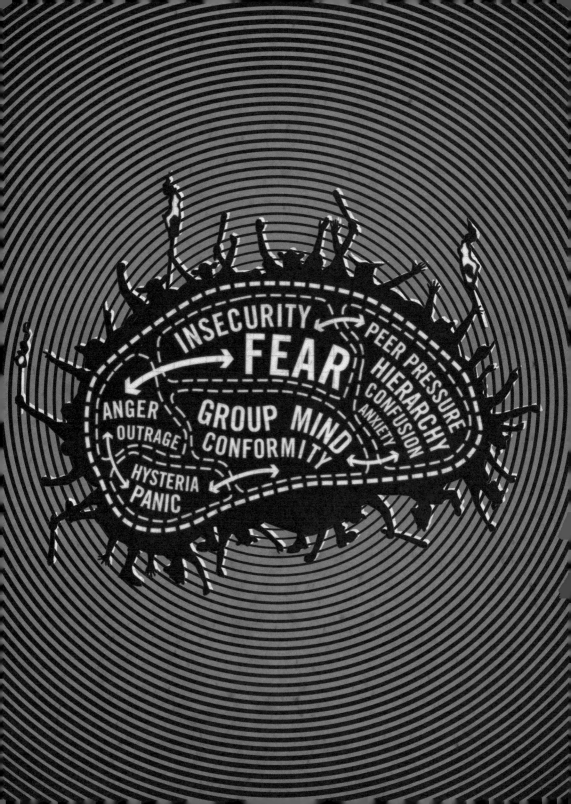

Mob mentality

A form of group-psychosis in which peer pressure and a fear of being isolated, sweeps all *cows* away individually, whilst binding them together in a form of mass hysteria.

In this state it is not the most reasoned or intelligent who lead the herd, but merely the whim of the strongest or most feared.

Eg. | Edward Bernays, *Propaganda*, 1928

"The group mind does not think in the strict sense of the word. In place of thoughts it has impulses, habits and emotions. In making up its mind, its first impulse is usually to follow the example of a trusted leader. This is one of the most firmly established principles of mass psychology."

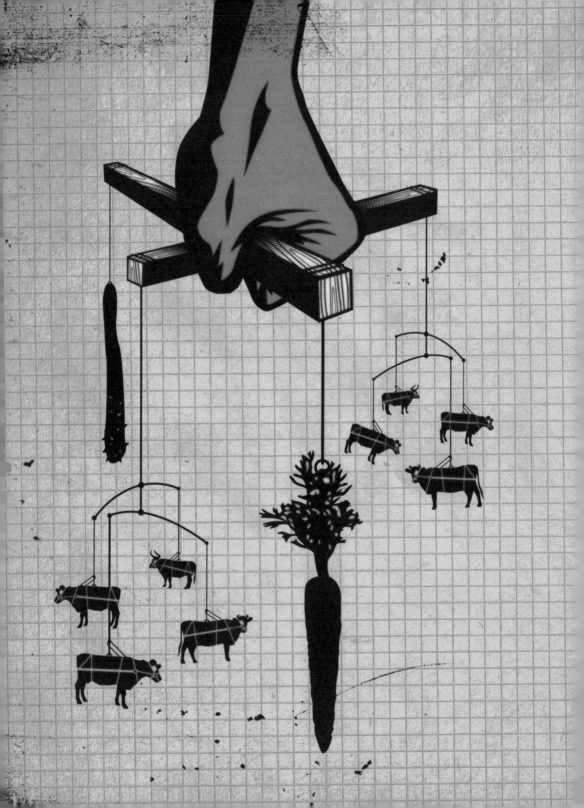

Harnessing the herd

Propaganda is used as a social harness which subliminally conveys appropriate threat and reward messages to control the herd's energy and behaviour, allowing the herd to be directed as *they* desire.

It is often a delicate balancing act when deciding between the carrot or the stick.

Eg. | Edward Bernays, *Propaganda*, 1928

"We are governed, our minds are moulded, our tastes are formed, our ideas suggested, largely by men we have never heard of... It is they who pull the wires which control the public mind, who harness old social forces and contrive new ways to bind and guide the world."

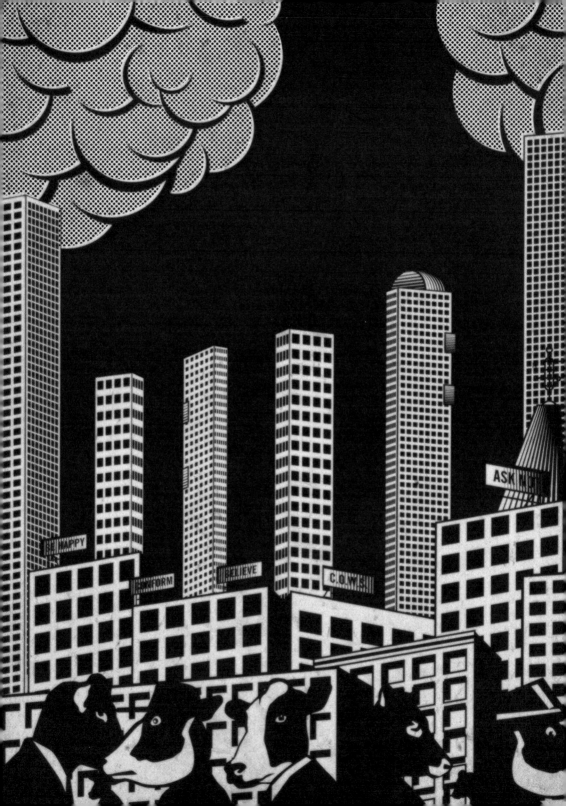

T.H.E.M.

The Hidden Elite Minority[*] are the true rulers of the world. *They* reach down in the cover of darkness to influence ████, governments, banking groups, corporations, military and intelligence networks. Through these institutions, *they* wield ultimate control.

[*]The Hidden Elite Minority will henceforth be referred to simply as *them* or *they* where necessary.

 | Joseph E. Stiglitz, *Vanity Fair.* May 2011.

"The Supreme Court, in its recent Citizens United case, has enshrined the right of corporations to buy government, by removing limitations on campaign spending. The personal and the political are today in perfect alignment. Virtually all U.S. senators, and most of the representatives in the House, are members of the top 1 percent when they arrive, are kept in office by money from the top 1 percent, and know that if they serve the top 1 percent well they will be rewarded by the top 1 percent when they leave office."

STEP 4: STRATEGY

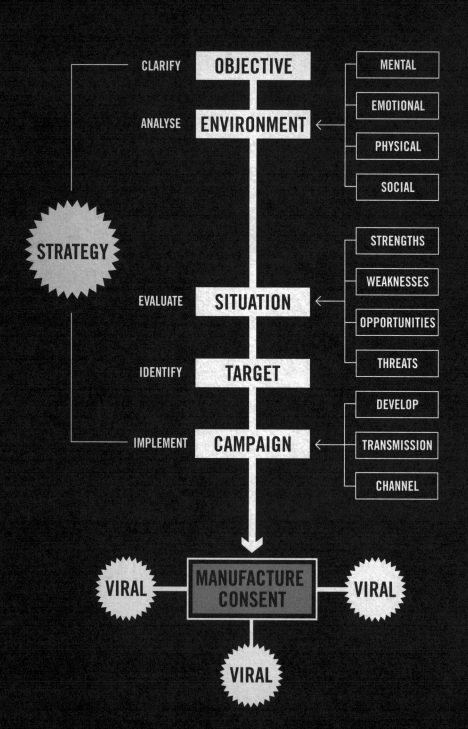

The objective of propaganda is to manage public opinion and manufacture the consent of the masses. Ideally, any new behaviour patterns will become virally self-perpetuating.

Planning a strategy for these ends requires comprehensive analysis and evaluation of the environment and situation.

Spinfluence needs to be built around an idea which has the potential for strong spin.

ENCOURAGE

AGITATE

DESENSITISE

SUPPRESS

Clarify objective

The tactical objectives
of propaganda are:

- Control the narrative.

- Arouse the interest
of a specific group.

- Nullify unhelpful ideas.

- Agitate or desensitise
the emotional state
of the target audience.

Eg. | Wolf&Co. *Planning Dept,* 1995

"During wartime, propaganda is used to mobilise the masses. Provoke hatred of
the enemy. Desensitise civilians to the atrocities committed by their own regime.
Demoralise the enemy. Preserve friendship of allies and influence neutral parties."

Analyse the environment

DELETE

The mental, emotional, physical and social environments are analysed in order to provide critical insight into the target audience's hopes, fears, dreams and desires.

Eg. | Wolf&Co. *Strategy Dept,* 2008

"There are now over 4.2 million CCTV cameras in the UK, more than one for every 14 people. Over 600 agencies are now authorised to access personal records. The National DNA Database permanently holds the details of nearly 4 million individuals. This degree of monitoring and surveillance allows for a very comprehensive analysis of the characteristics of society."

Evaluate the situation

Feelers are put out to evaluate the situation and detect opportunities for gain.

In this way, circumstantial strengths and weaknesses are flagged, and potential threats detected sooner rather than later.

Keep your friends close. And your enemies closer.

Eg. | Sun Tzu, *The Art of War*, 6BC

"All warfare is based on deception. Hence, when able to attack, we must seem unable; when using our forces, we must seem inactive; when we are near, we must make the enemy believe that we are far away; when far away, we must make him believe we are near. Hold out baits to the enemy. Feign disorder, and crush him."

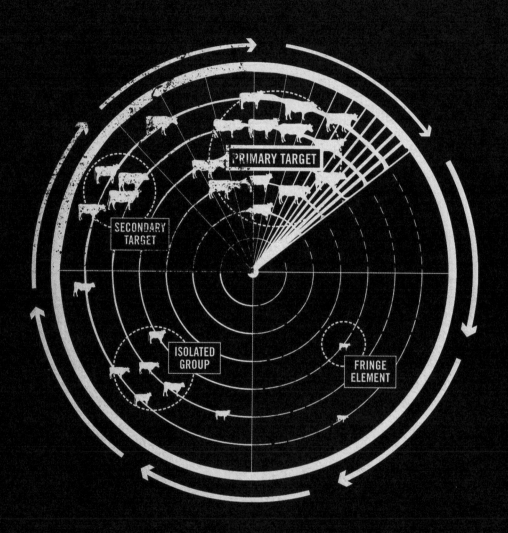

Identify the audience

Once the preliminary research is completed, the target audience becomes identifiable.

The target audience is the group whose role as early adopters of the desired behaviour is most required for our ~~blah~~ propaganda to be effective.

Eg. | Malcolm Gladwell, *The Tipping Point*, 2000

"The success of any kind of social epidemic is heavily dependent on the involvement of people with a particular and rare set of social gifts."

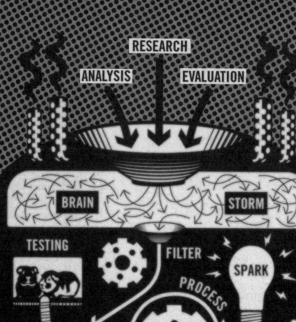

RESEARCH

ANALYSIS EVALUATION

BRAIN STORM

TESTING FILTER SPARK

PROCESS

SINGLE IDEA SPIN

SYMBOLS SYMBOLS SYMBOLS

CENTRAL
MESSAGE

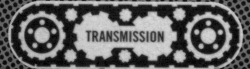

TRANSMISSION

CENTRAL
MESSAGE

ONGOING NARRATIVE

Develop campaign

Complex ideas are reduced down to their fundamental essence and condensed into symbolic messages.

Symbols are important as they are easily and immediately understood by a wide audience. They then play a key role in establishing the central message which is transmitted into the ongoing narrative.

 | **Andrew Sullivan,** *The Australian,* 15/01/07

"Wars... are not just about guns and military action. They are also about ideas and ideology. Long wars, especially, are won by those who gain control of the narrative. The West won the Cold War when it became understood globally as a battle between totalitarianism and freedom."

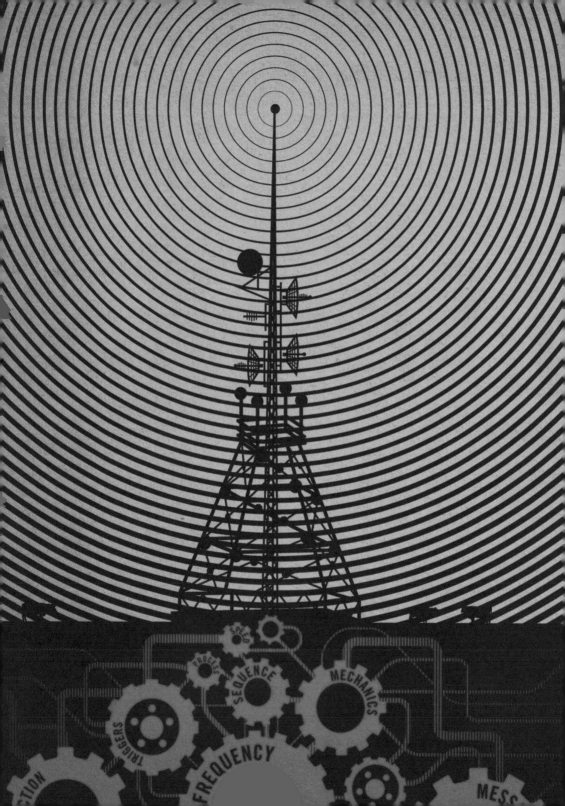

Transmission

Transmission is the action or process of broadcasting and disseminating the central message in the most effective, insidious or subversive manner.

Successful transmission relies on all components of the propaganda machine functioning smoothly, and as one.

Eg. | thefullwiki.org/Propaganda

"Propaganda campaigns often follow a strategic transmission pattern to indoctrinate the target group. This may begin with a simple transmission such as a leaflet dropped from a plane or an advertisement. Generally these messages will contain directions on how to obtain more information, via a web site, hot line, radio program, et cetera (as it is seen also for selling purposes among other goals). The strategy intends to initiate the individual from information recipient to information seeker through reinforcement, and then from information seeker to opinion leader through indoctrination."

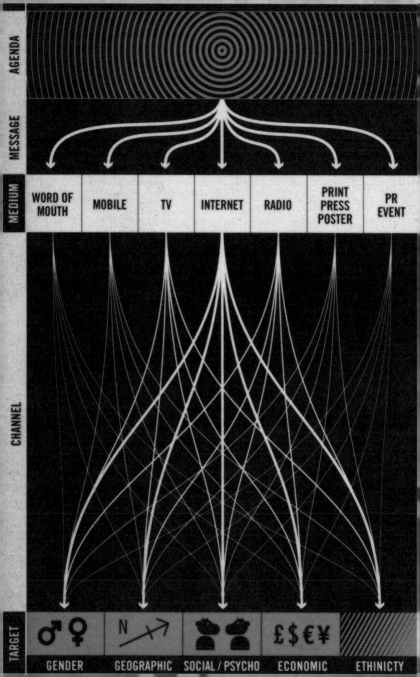

Channels

Traditional channels such as TV, radio and print still provide the widest reach to a broad target audience.

However, it is within the digital space – social media in particular, which is providing new and exciting methods of harnessing the herd.

 Gee Thomson, *Mesmerization,* **2008**

"New technology, the internet, broadband communications, mobile media and instant messaging have added an entirely new dimension to the power of such messages. Speed and rapid exponential growth have been added to the equation. Our contemporary commercial and media infrastructure, from lifestyle publishing to TV and the web, has both perfected the art of triggering emotional responses, using highly provocative visual metaphors, and providing a single and surprisingly coherent conduit for the worldwide dissemination and simplication of information."

STRATEGY 4.8

Viral

— Going viral to the point where it becomes an epidemic is the goal.

Memes are ideas which replicate and spread from person to person in a virally contagious manner through writing, speech, gestures, rituals or other imitable phenomena.

Highly contagious memes have the ability to spread like an epidemic, especially through social media.

Eg. | Gee Thomson. *Mesmerization,* 2008

"As well as spreading by word of mouth, memes are amplified by modern media: television, lifestyle magazines and now the internet. The large majority of memes which thrive today, by virtue of their repetition, volume, visibility and sheer weight in our media environment, are either commercial or conceal some commercial imperative."

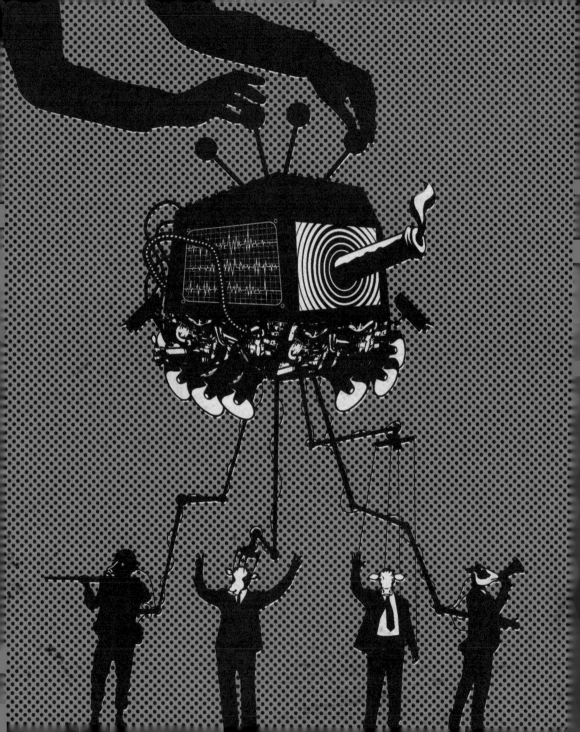

Manufacture consent

Public opinion is largely controlled through 'news' content which is broadcast through the mass media.

They are able to manufacture the consent of the masses by pressuring news outlets to ignore or place less emphasis on unfavourable news.

 | Robert Greene, *The Concise 33 Strategies of War*, 2008

"People's perceptions are filtered through their emotions; they tend to interpret the world according to what they want to see. Feed their expectations, manufacture a reality to match their desires, and they will fool themselves. The best deceptions are based on ambiguity, mixing fact and fiction so that the one cannot be disentangled from the other. Control people's perceptions and you control them."

STEP 5: TARGET

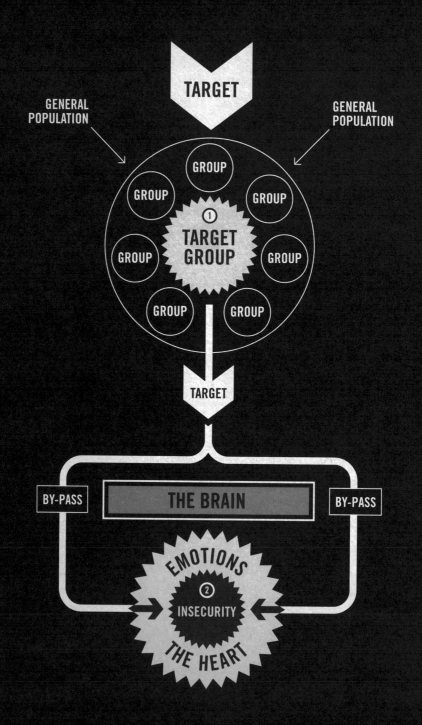

5.0 *TARGET*

Before spinfluence can work, the target must be identified on two levels:

1. Through social, geographic and economic demographics.

2. The heart: with its feelings and impulses which govern human behaviour at the most fundamental level.

Capture the heart and you capture the herd's happiness.

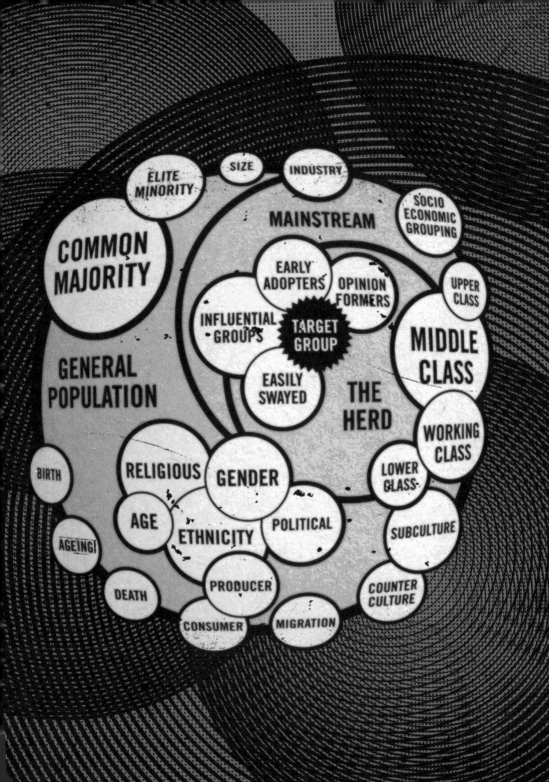

General population

Society is a complex melting pot of groups and subgroups who are in a continuous state of flux. There is a constant process of diversification, mutation and rejection, as these groups interact with one another. Understanding the big picture allows us to focus on the finer details.

 Edward Bernays, *Propaganda,* **1928**

"[Propaganda] takes account not merely of the individual, nor even of the mass mind alone, but also and especially of the anatomy of society, with its interlocking group formations and loyalties. It sees the individual not only as a cell in the social organism but as a cell organized into the social unit. Touch a nerve at a sensitive spot and you get an automatic response from specific members of the organism."

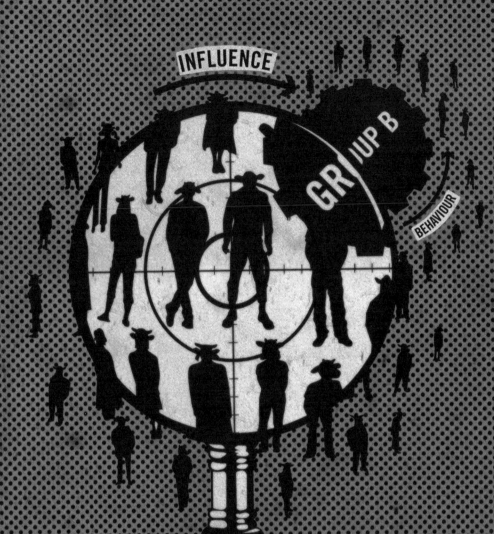

Target group

The target group is judged to hold a pivotal position within society, who will set the wheels of behavioural change in motion, through the influence they hold over other groups.

Therefore the propaganda produced must be tailored to their needs.

Thus the need for intelligent forward planning

 | Brian Solis, *Contagious*, Q2/09

"Motivating niche groups of enthusiasts may seem trivial, however, cultivating these specialized communities is the very thing that will install loyalty and trust, while sewing the seeds to ultimately empower an army of enthusiasts."

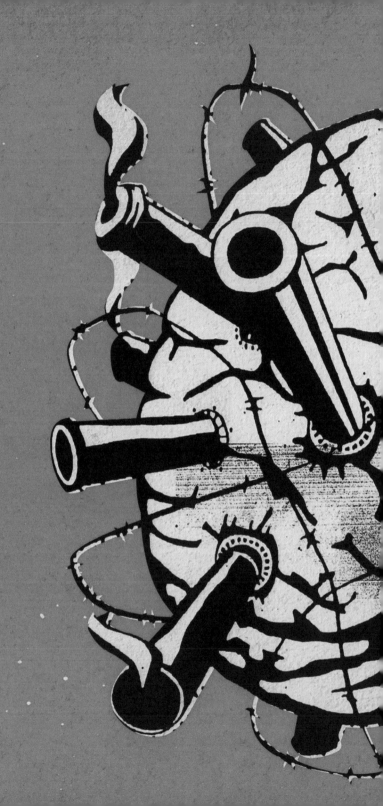

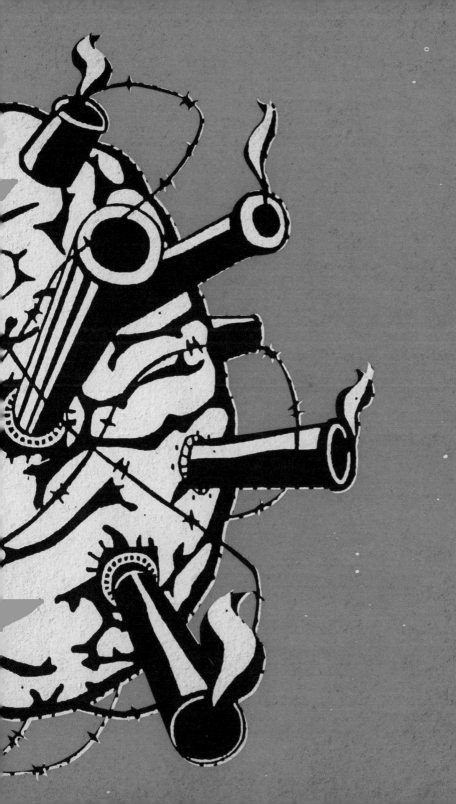

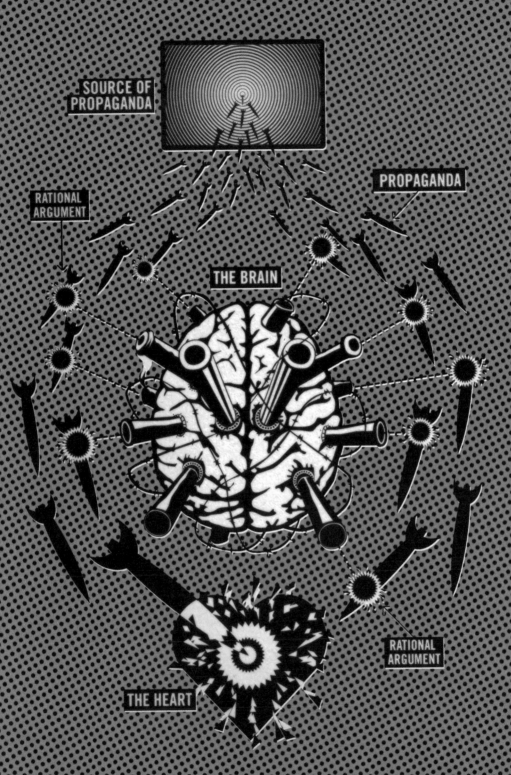

The brain

The brain is an obstacle on route to the heart.

It has the ability to make logical analysis and respond to propaganda with rational arguments. ~~Most~~ ~~~~ but ~~~~

Therefore, propaganda will always seek to bypass it in whichever way possible.

Eg. | William James, *Philosopher*, 1842–1910

"The greatest weapon against stress is our ability to choose one thought over another."

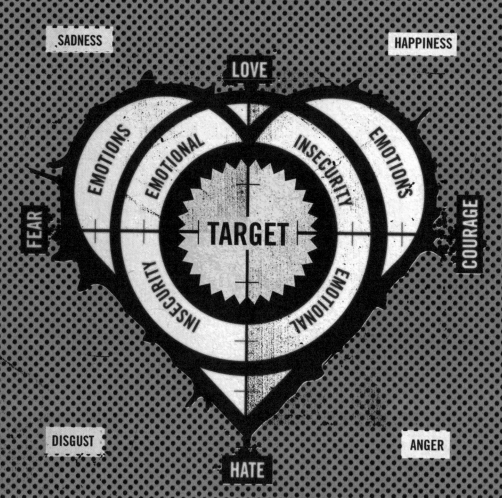

The heart

The heart sits at the core of human experience and it is where love, hate, fear and courage are commonly thought to reside.

It is emotions in which the *wolf* is most interested, as these can easily sway the decision-making process of the brain.

Eg. | Daniel Goleman, *Emotional Intelligence,* 1997

"The emotional/rational dichotomy approximates the folk distinction between 'heart' and 'head'; knowing something is 'right in your heart' is a different order of conviction – somehow a deeper kind of certainty – than thinking so with your rational mind. There is a steady gradient in the ratio of rational-to-emotional control over the mind; the more intense the feeling, the more dominant the emotional mind becomes – and the more ineffectual the rational mind."

Emotional insecurity

Propaganda targets the emotional tipping point where the defences of rational argument collapse under the weight of emotional insecurity.

In this state of uncertainty the target audience is more likely to make rash or uninformed decisions.

it's the split second decision making where it can go completely wrong.

Eg. | Gee Thomson, *Mesmerization*, 2008

"In the modern world, fear is ever present: from petty fashion and style concerns, insecurities over our weight, looks, food and health, to the bigger crisis beyond our control: nuclear disaster, terrorist attack and climate change, and the irrational: ghouls and psychotic monks, fears govern who we are and condition how we behave and react to the world."

Emotional reaction

An emotional reaction can be a positive or negative response to a change in an individual's status or situation.

Emotions are like shortcuts, allowing people to make instant decisions.

When faced with a threat, the reaction is most likely to manifest in a form of panic.

Eg. | Dan Gardner, *Risk, The Science and Politics of Fear,* 2008

"Every human brain has not one but two systems of thought. System One – Feeling... works without our conscious awareness and it is as fast as lightning. Feeling is the source of snap judgements that we experience as a hunch or an intuition or as emotions like unease, worry, or fear. A decision that comes from Feeling is hard or impossible to put into words. You don't know why you feel the way you do, you just do."

STEP 6: TRIGGERS

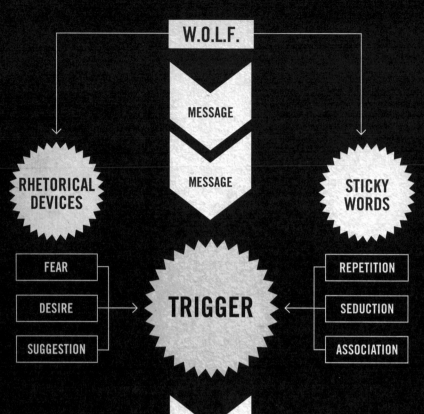

6.0 *TRIGGERS*

These are the mechanisms contained within a message which trigger an immediate primal response.

They stimulate emotions at a subliminal level, creating automatic behaviour patterns.

Triggers can be as simplistic as a word, colour, image, smell, or tone of voice.

Pulling a trigger releases the fight or flight survival instinct.

Fear

The deepest and most potent emotion a *wolf* can prey on is fear.

Fear is triggered to scare *cows* from looking too closely at what the facts might actually be.

In a mad panic, *cows* will scramble to take cover within the safety of the herd, instead of taking time to examine the validity of the source of their fear.

Eg. | **Ben Goldacre, *Bad Science*, 2008**

"Through the constant marketing of diseases, the pharma-industry is able to sustain economic growth and make profit through fear. Ironically, there are very few genuinely new treatments being developed, so 'the pill companies have instead had to invent new diseases for the treatments they already have.'"

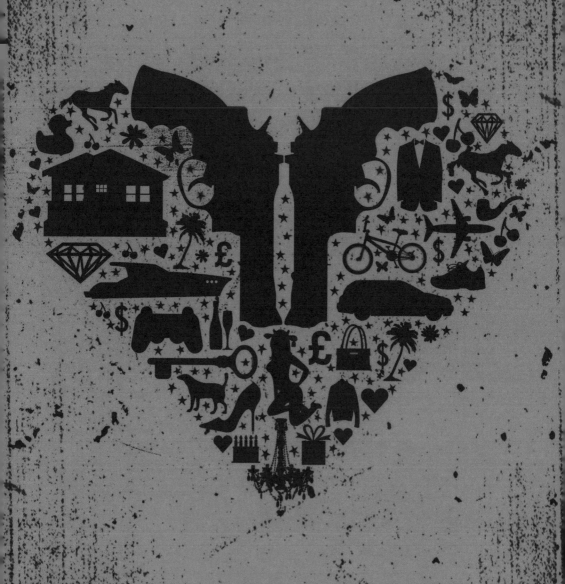

Desire

At the other end of the scale is ~~the end is of~~ desire.

Desire is a strong feeling of wanting, or wishing something would happen.

In the advertising industry, desire is the most commonly pulled trigger.

When used within the context of fear, it's power is doubled.

 | Adam Curtis, quoting a Wall Street banker, *The Century of Self*, 2002

"We must shift America from a 'needs' to a 'desires' culture. People must be trained to desire, to want new things, even before the old have been entirely consumed. [...] Man's desires must overshadow his needs."

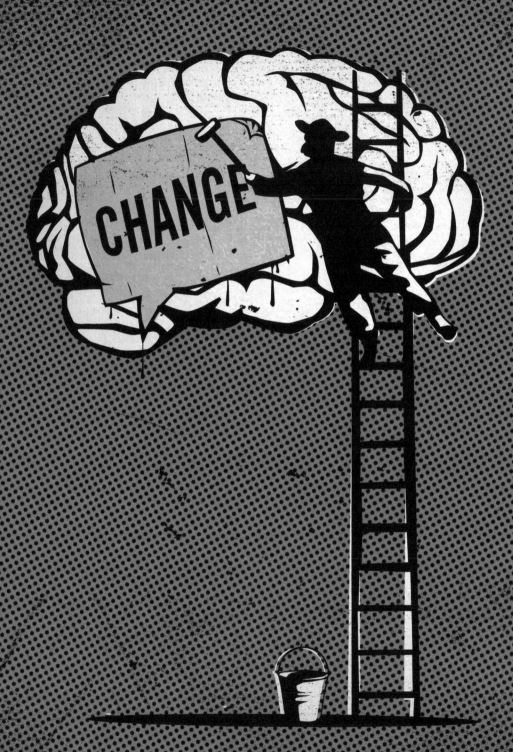

Sticky word

This is a single word which has the adhesive power to stick firmly in the mind of the herd.

It's adhesive quality is due to the fact that a multi-layered narrative has been condensed down into a simple slogan.

With a glue like quality it will hold in place as the winds of change attempt to blow it away.

Eg. | Wolf&Co. *Tech-sneak Dept,* 2010

"Barack Obama successfully stuck two words into the public psyche during the '08 election campaign – 'Hope' and 'Change'. Both of these words carried positive connotations which the herd could easily identify with. This enabled the Obama campaign to capture hearts and minds with abstract promises and without getting bogged down in policy details."

Suggestion

Direct talks to the head. Suggest to hit the heart.

A suggestion is the process of inducing one thought which in turn triggers another.

A suggestive remark involves the linking of words, concepts or symbols.

A suggestion is most powerful when it's touch is subtle enough to leave the person unaware of where they heard it first.

Eg. | *The Art and Science of Propaganda*

"An audience is more likely to accept an idea if they believe it was heard inadvertently. There is a natural tendency to resist a message that is presented in an assertive way, while there will be far less negative reaction if the audience hears the same theme in a context that is relatively 'matter of fact.'"

THEY DID IT THEY DID IT

THEY DID I

Repetition

Constant bombardment & reinforcement.

A statement repeated often enough, will in time, come to be accepted by the audience as the truth.

It works simply by flooding the public domain to a point where the herd can do no more than assume that what they are hearing is the truth.

Eg. | sourcewatch.org/repetition

"If you repeat something over and over, no matter how outrageous it may be, people will come to believe there's some truth in it. A good example of this is the claim that Saddam Hussein was responsible for the terrorist attacks of September 11, 2001. No evidence has been found suggesting collaboration between Iraq and the Al Qaeda network, yet Bush administration officials repeatedly mentioned the two in tandem. As a result, an opinion survey by the Council on Foreign Relations showed that more than 40 percent of the American people believe that some or all of the attackers on 9/11 were Iraqi nationals, when in fact none were."

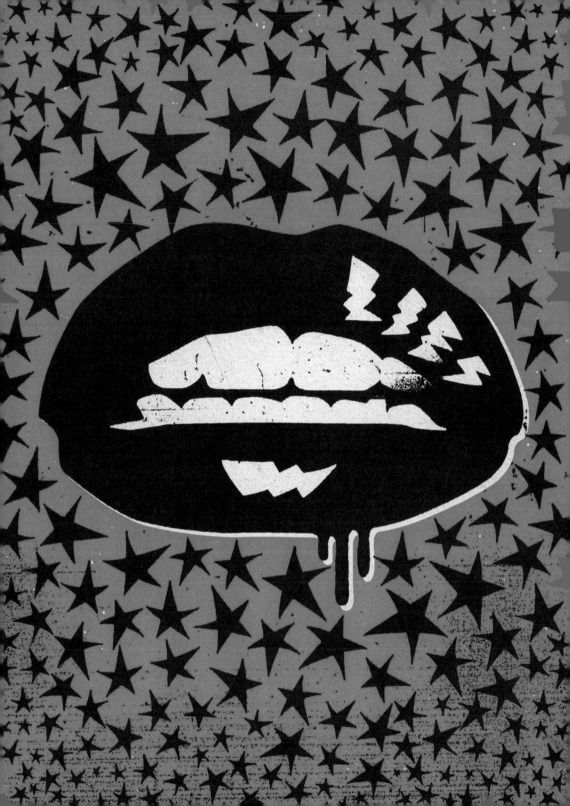

Seduction

Through the repetition of symbols, suggestive imagery and other stimuli, a primal lust is ~~[struck through]~~ *LANGUID* ~~triggered.~~ triggered.

The audience can be seduced into behaving in a certain way as though under a spell, captivated by a multi-sensory spectacle. ~~[struck through]~~

REMOVE ~~[struck through]~~

Eg. | Gee Thomson, *Mesmerization*, 2008

"Where pleasure and excitement are bonded to particular emotions within neural maps inside the mind, re-imprinting of the same input reinforces a sense of euphoria. Just as a painter finds the sublime in a landscape, or a priest is moved by an evocative passage in the Old Testament, young minds are becoming more turned on by interacting with digital worlds and virtual partners than with interaction with real people in normal life."

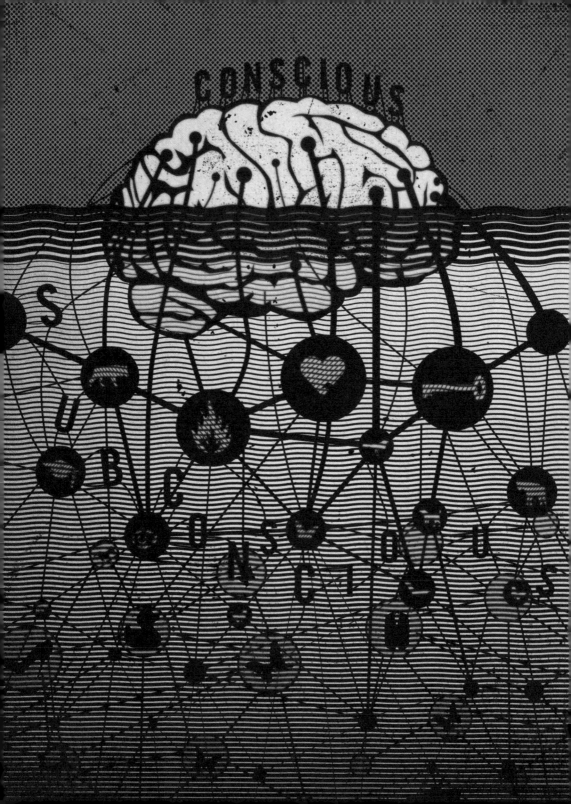

Association

Propaganda triggers emotions by activating subconscious networks of association.

A network is often based on the individual's past experiences, beginning with early childhood.

Memories buried deep down can be triggered, when their emotional associations are released – invoking behaviour change.

 Drew Western, *The Political Brain*, 2007

"From a psychological standpoint, the primary goal of every campaign appeal should be to elicit emotions that *move the electorate*. And that means activating, reinforcing and creating networks that associate your candidate or party with positive emotions and the opposition with negative emotions."

STEP 7: SPIN

7.0 *SPIN*

The technique in which propaganda enters the narrative and infiltrates the audience's thoughts and feelings.

A well delivered message which has had the correct amount of spin applied to it, will allow the audience to remain unaware that any such incursion has taken place.

Blissful ignorance truly does pave the way to compliance through conformity.

Negative spin

A story is given a negative spin in the hope that the audience will reject and condemn the person or people charged, on the basis of the accusation alone, instead of looking at all of the evidence.

 Andy Greenberg, *Forbes.com,* 5/30/11'

By focusing on Julian Assange, the mainstream media deliberately attempted to put negative spin around WikiLeaks so as to obscure the critical importance of the issues it champions such as publishing the truth about war and transparency in government.

'"Frontline's WikiLeaks documentary was seen by some as a negative spin on the leaking group's story that emphasized Bradley Manning's emotional problems and highlighted the accounts of WikiLeaks' critics. In response to the program, WikiLeaks released its own unedited video of PBS's interview with WikiLeaks founder Julian Assange, and warned that the show is "hostile and misrepresents WikiLeaks' views and tries to build an 'espionage' case against its founder, Julian Assange, and also the young soldier, Bradley Manning."

Positive spin

DELETE

Positive spin is given to a story in an attempt to make the audience approve and accept a person or idea without examining all of the evidence thoroughly.

Eg. | Joseph E. Stiglitz, *Vanity Fair*. May 2011

"The corporate executives who helped bring on the recession of the past three years—whose contribution to our society, and to their own companies, has been massively negative—went on to receive large bonuses. In some cases, companies were so embarrassed about calling such rewards "performance bonuses" that they felt compelled to change the name to 'retention bonuses.'"

Euphemism

When referring to an unpleasant or embarrassing event, euphemisms can be used to make things sound better than they really are.

A euphemism is a mild or less direct word substituted for one considered too harsh, blunt... or honest.

Eg. | Christiaan Briggs, *Last-Straw.net*, 2010

"The euphemistic term 'ethnic cleansing' is used by governments and complicit media outlets in instances of 'genocide', where they wish to relieve themselves of their legal obligations under the Genocide Convention to 'prevent' the genocide. One of the most notorious examples of this was Srebrenica, Bosnia, 1995."

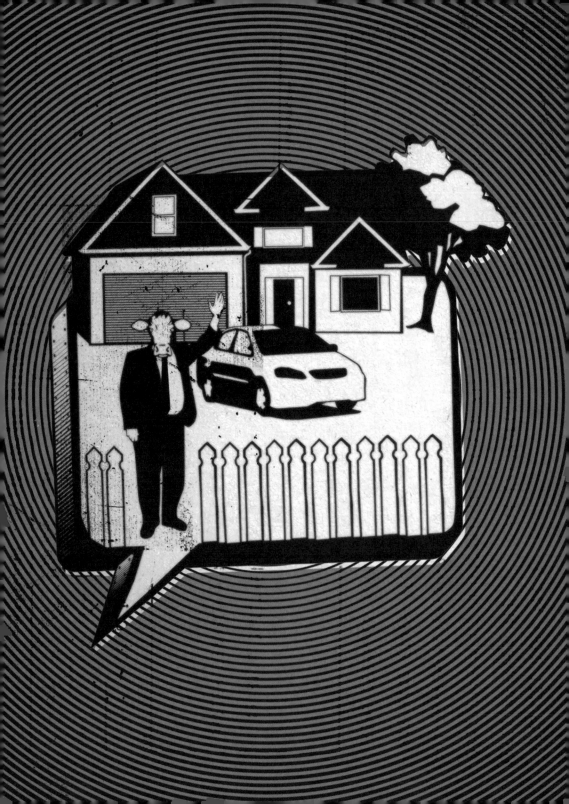

Common touch

This technique is used to give the impression that *they* hold the people's best interests close to their heart.

Emphasis is placed on the commonality of their values with that of the ordinary citizen.

 Eg. | Eli Saslow, *Washington Post.com,* 2008

"Presidential candidates have strived relentlessly downward in social class ever since the 1840s... With few exceptions since, American voters have picked presidents who mimic the public's most ordinary habits – men who regularly mention drinking, or NASCAR, or old-fashioned farm work. Ronald Reagan liked to be photographed chopping wood. George H.W. Bush spoke longingly about pork rinds. Bill Clinton stopped at McDonald's while on the campaign trail, even when it required a side trip. And George W. Bush is a champion bush-clearer."

Salt of the earth... street cred. This earns street cred.

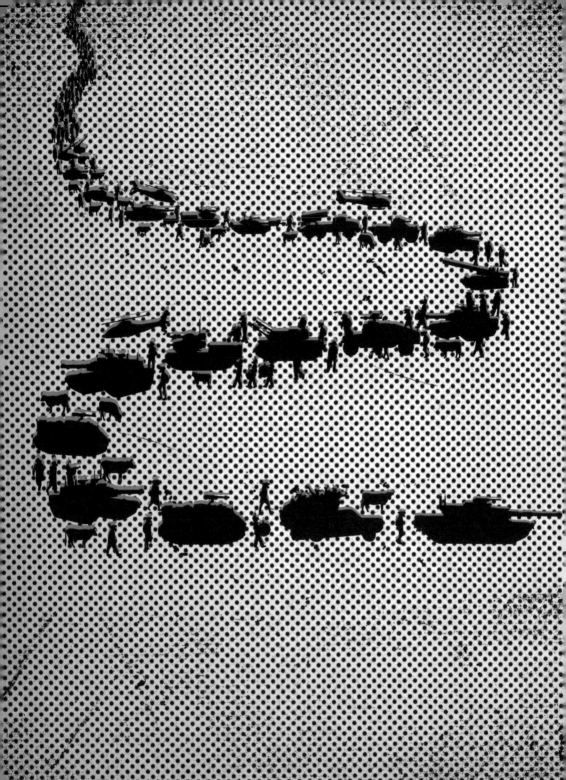

Bandwagon

The bandwagon technique is used to create the illusion that everyone is backing a particular movement. It appeals to the common desire to follow the herd, whilst reinforcing the fear of being left behind.

Eg. | [1]Steven Poole, *Unspeak, Words are Weapons*, 2006

George W Bush put the bandwagon in motion by stating "You're either with us or against us in this fight against terror" creating a false dilemma that neutrality was not an option. The idea that the international community was behind the US led invasion was perpetuated when "newspapers and TV stations adopted the phrase 'Coalition of the Willing', or even just the shorthand 'coalition', to describe the March 2003 invasion of Iraq conducted by overwhelmingly US and British forces, they quietly endorsed the idea that this was a far reaching alliance which only a few obstreperous or sulky nations opposed."[1]

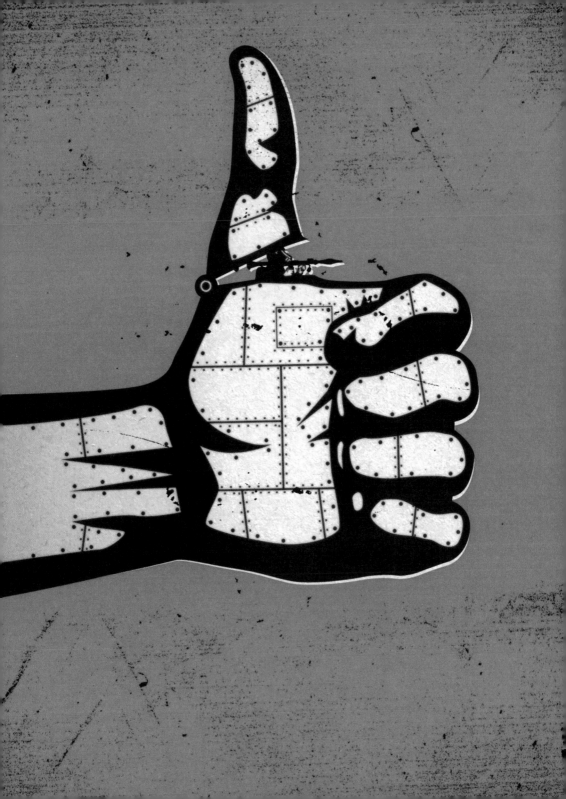

Testimonial

A testimonial is an endorsement from a respected individual who holds public favour in one field, yet has no expertise in another.

DELETE

... too happy ...

Eg. | *BBC News, 22/02/03*

In the lead up to the invasion of Iraq, Tony Blair visited Rome to try and obtain the Pope's blessing for the invasion. Although he failed to secure an endorsement, Blair framed the Pope's response as being a testimonial with common ground between the two: *"What the words of His Holiness the Pope have described... is the reluctance of people to go to war except as a last resort. That is our position."

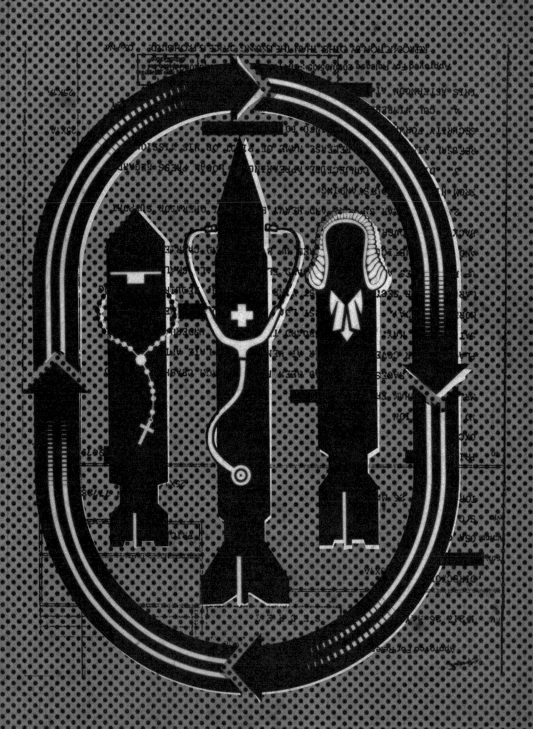

Transfer

By transferring the prestige and authority which the audience already has for a respected institution, the *wolf* secures the audience's acceptance for an agenda which may otherwise have been rejected.

 Dominic Rushe, Jill Treanor, *The Guardian*, 11/12/12

"Federal investigators found that one of the world's largest banks, HSBC, spent years committing serious crimes, involving money laundering for terrorists; 'facilitat[ing] money laundering by Mexican drug cartels'; and 'mov[ing] tainted money for Saudi banks tied to terrorist groups'. [However,] not only did the US Justice Department announce that HSBC would not be criminally prosecuted, but outright claimed that the reason is that they are too important, too instrumental to subject them to such disruptions. In other words, shielding them from the system of criminal sanction to which the rest of us are subject is not for their good, but for our common good."

This travesty of justice is able to occur due to people's blind faith in the legitimacy of authority. People accept this situation partly because the prestige of the US Justice Department has been transferred over to HSBC.

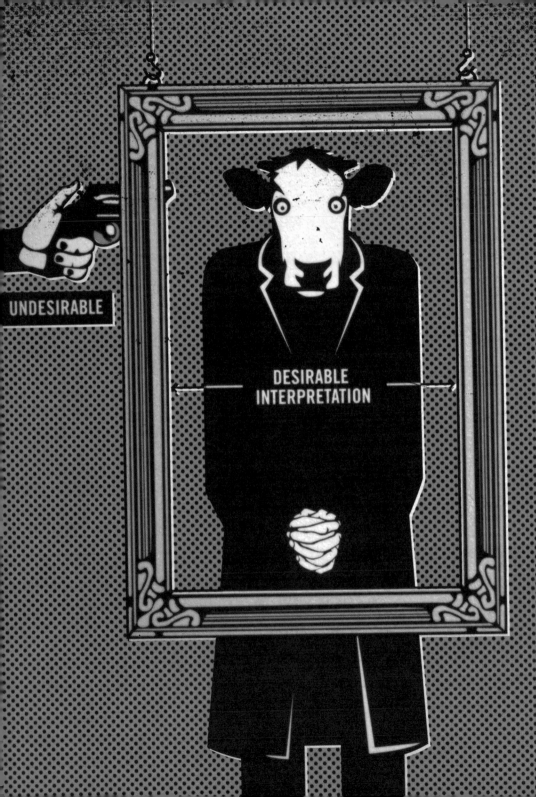

Framing

Framing is the process of selective control over message content or media communication.

Framing defines how the message is packaged so as to allow certain desirable interpretations in, and rule others out.

Eg. | *Address to a Joint Session of Congress, 20/09/01*

George W Bush framed the motive for the attack on 911 in strikingly narrow terms when he stated: "They hate our freedoms – our freedom of religion, our freedom of speech, our freedom to vote and assemble and disagree with each other."' This statement does not allow room to consider American foreign policy as a possible motive for the atrocity.

STEP 8: FILTERS

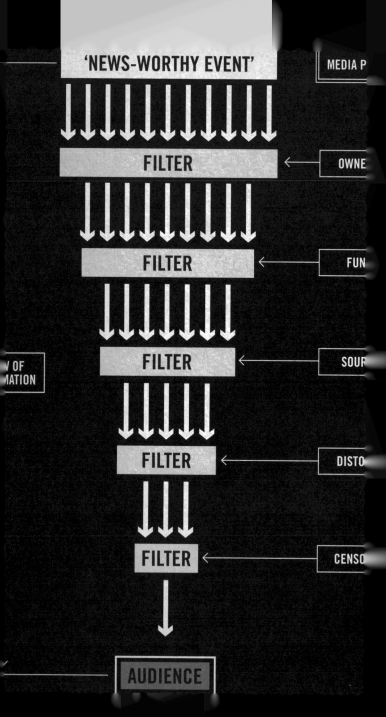

'NEWS-WORTHY EVENT'

MEDIA P

FILTER ← OWNE

FILTER ← FUN

FILTER ← SOUR

/ OF
MATION

FILTER ← DISTO

FILTER ← CENSO

AUDIENCE

8.0 FILTERS

Mainstream mass media outlets are all owned and operated by large corporations.

To maximise profits they will shift their emphasis both onto and away from government and business as deemed expedient.

They are able to filter the news, fix the premise of discourse and define what is newsworthy.

The herd will happily swallow everything labeled 'news'.

Ownership

The world's media giants are essentially businesses which are profit-orientated, owned and controlled by *them,* and who have close links to other large corporations, banks and governments.

REMOVE

Eg. | Edward S. Herman & Noam Chomsky, *Manufacturing Consent,* 1988

"Leaders of the media claim that their news choices rest on unbiased professional and objective criteria... If, however, the powerful are able to fix the premises of discourse, to decide what the general populace is allowed to see, hear and think about, and to "manage" public opinion by regular propaganda campaigns, the standard view of how the [mass media] system works is at serious odds with reality."

Funding

Advertising is the primary source of funding for most mass media outlets.

As a result, media outlets rarely broadcast or print programmes or messages which are likely to upset and thereby marginalise themselves from their advertisers' patronage.

A side effect of capitalism means 'its ALL for sale

 Eg. | Edward S. Herman & Noam Chomsky, *Manufacturing Consent*, 1988

"Large corporate advertisers on television will rarely sponsor programs that engage in serious criticisms of corporate activities, such as... the workings of the military-industrial complex, or corporate support of and benefits from Third World tyrannies."

Sourcing

The mass media's primary source of information about, and concerning the government is provided through press releases.

This creates a convenient filter where 'experts offering objective analysis' is in reality only an echo of the official line.

 Eg. David Barstow and Robin Stein, *nytimes.com,*
Under Bush, a New Age of Prepackaged TV News, **13/03/05**

"An important instrument of this strategy [prepackaged TV news] was the Office of Broadcasting Services, a State Department unit of 30 or so editors and technicians whose typical duties include distributing video from news conferences. But in early 2002, with close editorial direction from the White House, the unit began producing narrated feature reports, many of them promoting American achievements in Afghanistan and Iraq and reinforcing the administration's rationales for the invasions. These reports were then widely distributed in the United States and around the world for use by local television stations."

Distortion

A deliberately misleading or prejudiced interpretation of events leads to a ~~████████~~ ~~████~~yable distortion of the truth.

By highlighting trivial aspects of a 'news story' whilst ignoring its major factors, the audience's comprehension of the event is also distorted.

Eg. | Aldous Huxly, *Brave New World Revisited*, 1958

"A dictatorship... maintains itself by censoring or distorting the facts, and by appealing not to reason, not to enlightened self-interest, but to passion and prejudice, to the powerful 'hidden forces', as Hitler called them, present in the unconscious depths of every human mind."

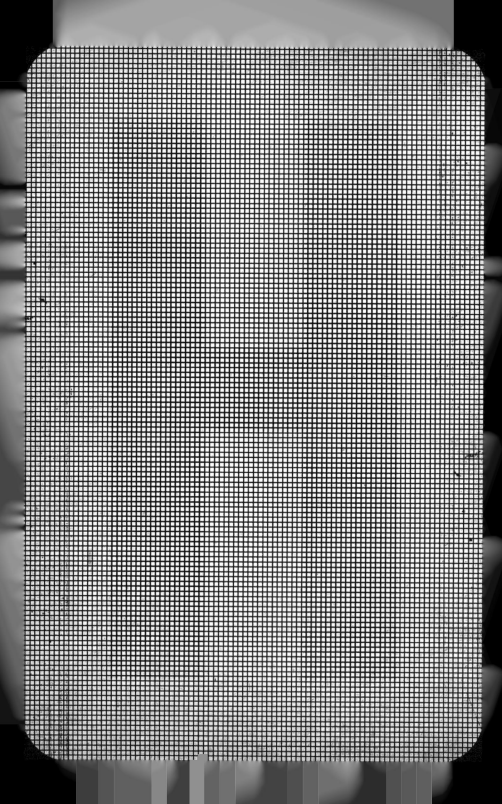

ultimately this is a key foundation of controlling the masses.

Censorship

The suppression or deletion of material which may be considered harmful.

Political censorship occurs when governments hold back information from their citizens in order to exert control over the herd and prevent free expression that might encourage rebellion.

 Eg. | Randy James, *time.com, Chinese Internet Censorship*, 18/03/09

"In China, *The Golden Shield Project* blocks web sites on an array of sensitive topics (democracy, for instance), while tens of thousands of government monitors and citizen volunteers regularly sweep through blogs, chat forums, and even e-mail to ensure nothing challenges the country's self-styled *harmonious society*."

STEP 9: TACTICS

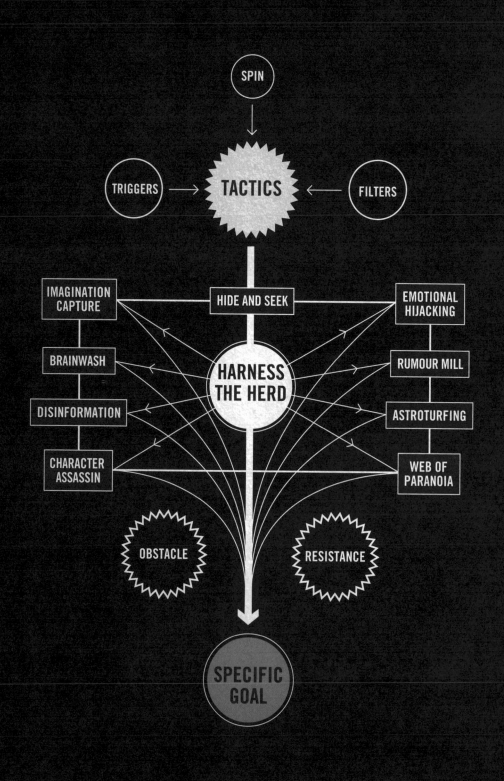

9.0 TACTICS

There are a wide variety of tactics which a *wolf* can take advantage of to harness the herd and drive *cows* in any chosen direction.

Whether it be deception, persuasion or assassination – the most appropriate method to madness needs to be found.

There will always be obstacles and resistance, so adaptability is a key attribute which the Young Cub must learn to master.

Hide and seek

When the source of propaganda is intended to be obvious – as it is with the majority of advertising, it is referred to as being 'white propaganda'.

In this case the *cow* knows who the message is from and will seek out more information if they so wish.

Where the true source is disguised, the term 'black propaganda' is used.

In an attempt to deceive and confuse the enemy further, it may be portrayed as coming from the enemy's own side of the conflict, through the fabrication of communications.

Eg. whatreallyhappened.com/cointelpro

"Black operations ... are designed to be attributed to the other side and must be carried out by a secret agency in order to hide the actual source of the propaganda. A black radio purportedly broadcasting from Central Asia or a forged document purportedly coming out of the classified files of a Soviet embassy requires expertise, secret funds, and anonymous participants."

Imagination capture

A big idea – inspiring in it's grandeur yet deceiving in it's simplicity is what's required to effectively harness the herd.

In doing so, the *wolf* is able to capture their imagination and either motivate behaviour change or crush their will and spirit.

New thinking which blows your mind.

 | **George Louis (Advertising Guru), 2011**

"The big idea: solving a specific communications problem with an audacious blend of words and images that catch people's eyes, penetrate their minds, warm their hearts, and cause them to act."

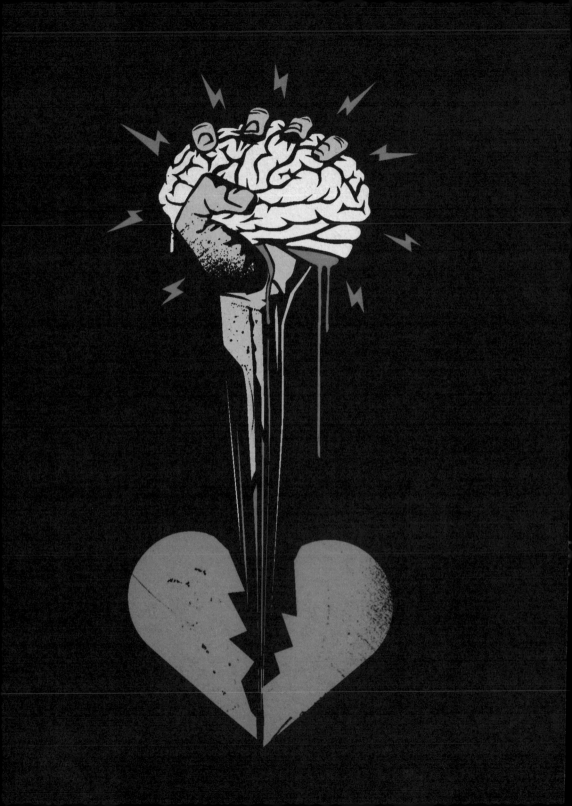

TACTICS 9.3

Emotional hijacking

Emotional hijacking occurs when a *cows* rational mind is overcome by his or her ▬▬▬▬▬▬▬▬▬▬ emotions.

This is often in response to a situation that provokes fear and subsequent panic.

As a result, an individual's decision making ability suffers.

Eg. | Daniel Goleman, *Emotional Intelligence, 1997*

"Emotional explosions are neural hijackings... a center in the limbic brain proclaims an emergency, recruiting the rest of the brain to its urgent agenda. The hijacking occurs in an instant [before] the thinking brain has had a chance to glimpse fully what is happening, let alone decide if it is a good idea. The hallmark of such a hijack is that once the moment has passed, those so possessed have the sense of not knowing what came over them."

Web of paranoia

Paranoia is a disturbed mental condition characterized by anxiety, fear, and irrationality. Paranoid thinking typically includes delusions of persecution.

A *wolf* will spin the web to foster these conditions at group level, amplifying the perception of danger and inducing a state of paralysis.

Eg. | Alexander Cockburn & Jeffery St Claire, *Counter Punch. Journalism that rediscovers America,* 2002

"Americans are being slowly indoctrinated into believing that they are citizens of a nation under siege, beset by evil forces both within and without. Inspired by the Bible-thumping rhetoric of their beloved right-wing Christian leaders."

Astroturfing

EDACT

~~is simply trying to~~ ████████████████ ~~The~~ term refers to the planting of supposed 'grass root' campaigners behind a politician or corporate spokesperson in position, likely to receive high media exposure, with the aim of creating the illusion of genuine support.

plant people to look popular.

Eg. | sourcewatch.org/index.php?title=Astroturfing

"Corporations such as Philip Morris Tobacco Company have funded front groups which are created by PR companies. In this case, The National Smokers' Alliance was set up as a grass roots, front group to give the appearance of genuine opposition to smoke-free laws without its corporate involvement being detected."

Disinformation

The deliberate dissemination of false information – statements and innuendo intended to manipulate the audience at a rational level.

The fabrication of intelligence is used to support false conclusions and mobilise bias.

 Eg. | sourcewatch.org

"A common disinformation tactic is to mix truth, half-truths, and lies. Disinformants sometimes seek to gain the confidence of their audience through emotional appeals or by using semi-neutral language interlaced with threads of disinformation.
A group might plant disinformation in reports, press releases or public statements. Disinformation is often leaked or covertly released to a source trusted to repeat the false information."

Rumour mill

A rumour is a story or report which is circulated to explain uncertain events. As a rumour spreads, it "grows shorter, more concise and is more easily grasped and told".

Rumour transmission is a type of collective explanation process.

He said that she said...

"Apparently "they" said that...

FLOW OF INFORMATION GOSSIP TITTLE-TATTLE WHISPERS

A 'rumour mill' is a term used to refer to both the place and activity of generating rumours. Under the right conditions it is possible to manipulate or usurp the mill with the intention of pumping specific messages into the public domain.

Echo chamber

The echo chamber effect occurs when news and media outlets repeat and parrot a single source without cross checking the facts. It reverberates throughout the press until it reaches the mainstream where it is assumed to be fact.[3]

sourcewatch.org

FLOW OF SCANDAL HEARSAY TIDBITS

Brainwashing

popular with cults.

Brainwashing is a form of coercive persuasion which aims to cloud and wash away rational thought. This can result in a person being seduced into accepting what would otherwise be abhorrent.

 | Kathleen Taylor, *The Guardian, Thought Crime,* 8/10/05

"We need to think of brainwashing more realistically: not as black magic but in secular, scientific terms, as a set of techniques that can act on the human brain to produce belief change. People do, in certain circumstances, undergo dramatic changes of belief over startlingly short periods of time."

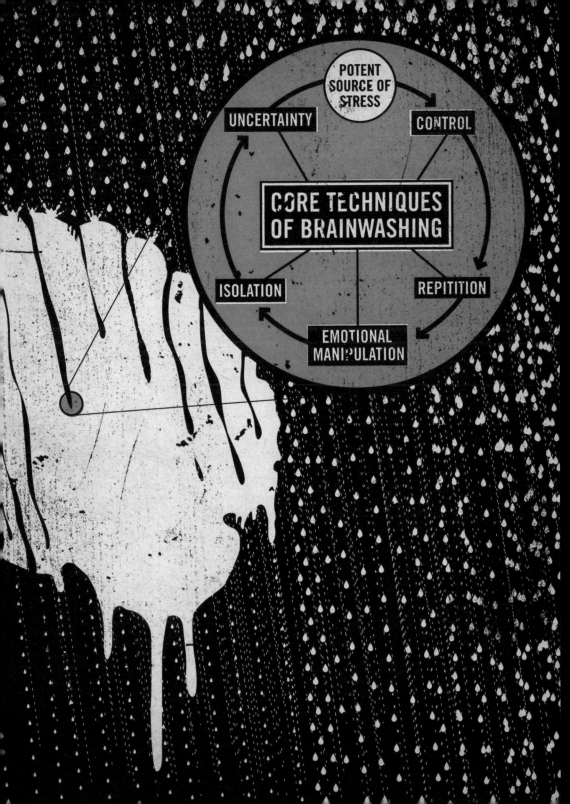

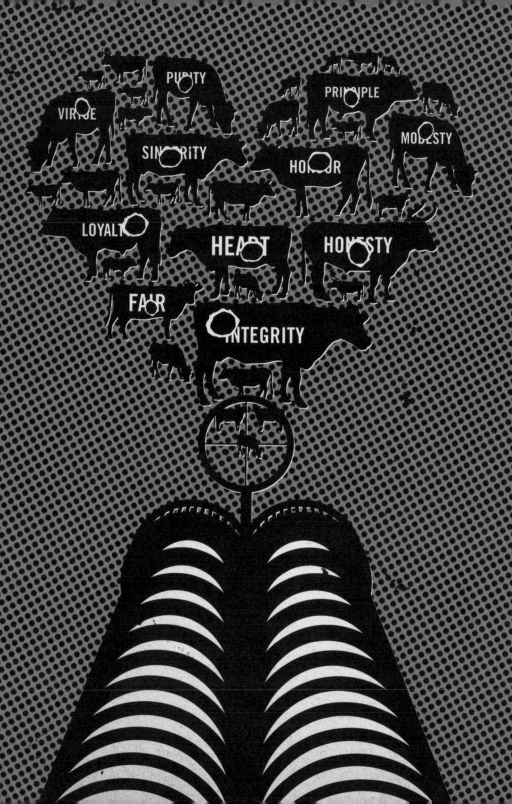

Character assassination

The intentional attempt to portray a particular person in a manner which will cause others to perceive him or her in a negative light.

By targeting the person's reputation and firing misleading innuendoes at their character it is possible to inflict a fatal blow

 Eg. | Wolf&Co. *A-tactics Dept*, 2009

"The Obama Nation: Leftist Politics and the Cult of Personality, published during the '08 US Presidential Election Campaign was a right-wing character assassination. The author's intent was to smear Obama's reputation with claims of "extreme leftism' and 'extensive connections with Islam and radical politics.'"

STEP 10: THE BLACK ART

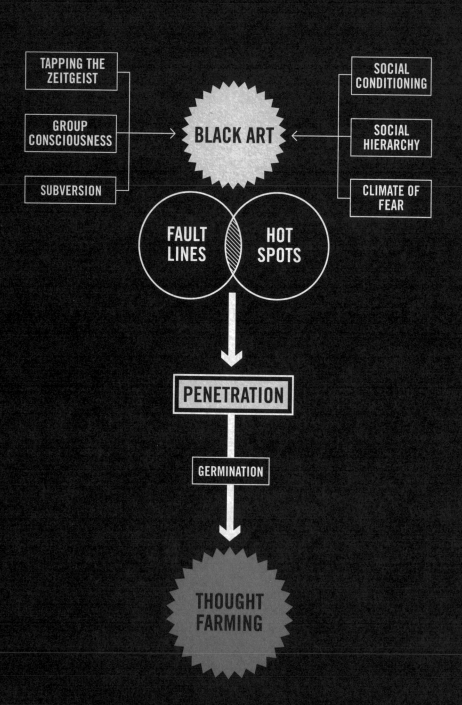

10.0 THE BLACK ART

The black art of Spinfluence is built on understanding the intangible nature of group consciousness and the ability to tap into the Zeitgeist.

This involves a meticulous examination of the herd and identification of social fault lines and hotspots.

Spinfluence is only truly achieved once the collective psyche of the herd has been penetrated and fertilised.

INTELLECTUAL

TIME

CULTURE

FLOW

PROGRESS

TRENDS

MOVEMENTS

FADS

PEOPLE / SOCIETY

H E A R T

TAP

ZEITGEIST

LOCATION

Tapping the zeitgeist

Zeitgeist translates as 'the spirit of the age' and describes the intellectual and cultural climate of an era. Tapping into the zeitgeist means being at the cutting edge of sociocultural progression. From this position, trends and movements can be identified and exploited for commercial or political gain.

 | Wolf&Co. *Morose Dept*, 2008

"Contemporary culture is dominated by the 'cult of celebrity' – the mass idolisation of popular culture personalities. A *wolf* should learn to exploit these cult followings by persuading its figureheads to endorse an idea or product. Equally, the cult of celebrity is useful in deferring attention from unwanted press. Newsworthy stories move to the back pages as papers fill their prime space with celebrity gossip and scandal."

FEAR

REPETITION

LOVE
BELIEFS
INSECURITIES
PREJUDICES
IDEALS
GUILT
MYTHS
HOPES
HATRED
FEARS
DESIRES
ASPIRATIONS
DREAMS

DESIRE

SEDUCTION

SUGGESTION

ASSOCIATION

Group consciousness

The ideas and beliefs which are held in common, bind together to form the group's consciousness.

This acts as a psychic gateway into the heart of the community.

The secret to Spinfluence is selecting the right key with which to unlock the gate. Once inside, the *wolf* is free to prey upon the values which are fundamental to the community's sense of identity.

Eg. | Jacques Ellul, philosopher, 1912 – 1994

"Emotional ideas, ranging from hopes to fears are what provide the richest material for the grand themes of propaganda. Tapping into these ideas and predicting the relevant ones and which ones hold the most sway with the greatest majority is what the propagandist studies: 'The goal of modern propaganda is no longer to transform opinion but to arouse an active and mythical belief.'"

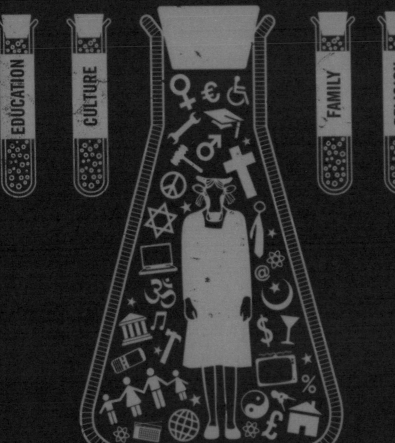

Social conditioning

Social conditioning refers to the absorption of social patterns, structures and codes of conduct, through influencing elements such as education, popular culture, family life and religion.

Cows are fully conditioned members of society who have adopted most, if not all, forms of conformist behavior.

 Erich Fromm, *To Have or to be?*, 1997

"The growing person is forced to give up most of his or her autonomous genuine desires and interests, and his or her own will and to adopt a will and desires and feelings that are not autonomous but superimposed by the social patterns of thought and feeling. Society, and the family as its psychosocial agent, has to solve a difficult problem: How to break a person's will without his being aware of it? Yet by a complicated process of indoctrination, rewards, punishments, and fitting ideology, it solves this task by and large so well that most people believe they are following their own will and are unaware that their will itself is conditioned and manipulated."

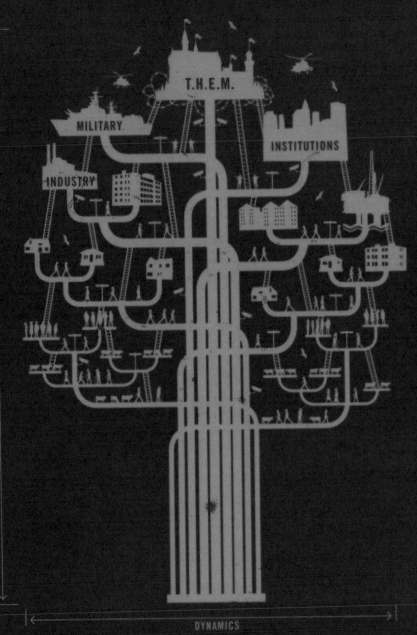

Social hierarchy

Social hierarchy is the ranking of people or groups above and below each other in accordance with their status and authority.

A *wolf* understands the common desire to move upwards and fools the herd into believing they are doing so, when in fact any progress is restricted to the lower branches of society.

 Eg. | Gee Thomson, *Mesmerization,* 2008

"Competitive concerns, anxieties over our status and our positional worth compared to our neighbours, friends and family are some of the most powerful controllers of behaviour. In contemporary culture, such comparisons are that much more acute when those 'friends' and 'neighbours' are the world's most glamorous celebrities, brought into the intimacy of our homes by reality TV, the internet and lifestyle magazines."

Fault lines and hotspots

Fault lines run along cultural divides such as race, religion and social status. A *wolf* will identify a hot spot of intolerance and fan the flames of bias to ignite radicalisation. Intolerance towards the other group's differences turns fault lines into open divides. Once divided, the herd is easily conquered.

 Gee Thomson, *Mesmerization*, 2008

"Resignation of one's autonomy to the group... devolves one of responsibility. Scientific research has shown that we have a natural propensity to form groups for our own protection. Part of that defence includes a prejudice to those outside our circle. Such discriminations can easily be inflamed to create radicalisation and violence."

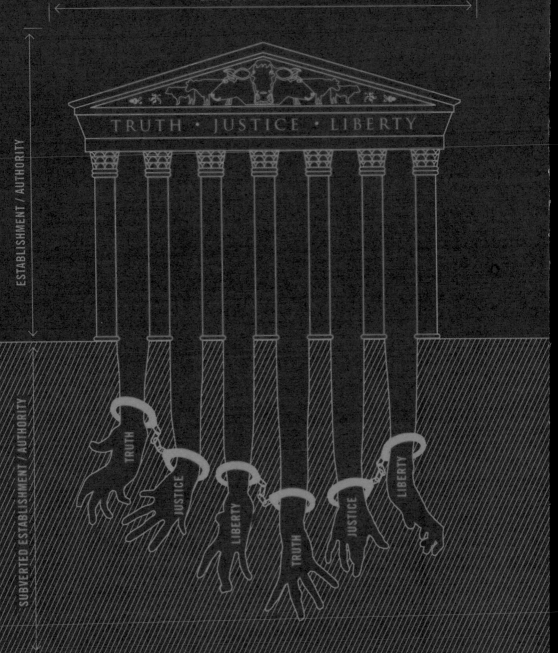

Subversion

A *wolf* builds up trust with the herd by portraying our client as having integrity and strong moral conviction. Once this position has been established, the *wolf* is able to undermine and subvert these very values which were proudly displayed.

Once integrity is subverted, corruption becomes inevitable.

 Anon, source unknown

"Democracy is subverted when a foreign power installs and supports a puppet regime in the name of freedom and independence for the people. This has been the case for many Central and South American military dictatorships which the U.S. has covertly supported to further their foreign policy objectives, despite a great loss of life."

Climate of fear

The desired atmosphere in which to foster paranoid subservience, is one of toxic anxiety with the occasional lightning bolt of outright terror.

Fear drives the media. Media drives hype. And hype drives fear. It is these factors, kept in constant motion which creates a perpetual climate of fear.

Eg. | Dan Gardner, Risk. *The Science and Politics of Fear,* 2008

"The media are in the business of profit, and crowding in the marketplace means the competition for eyes and ears is steadily intensifying. Inevitably and increasingly, the media turn to fear to protect shrinking market shares because a warning of mortal peril – 'A story you can't afford to miss!' – is an excellent way to get someone's attention."

Penetration

Penetration involves the ~~REDACT~~ process of inserting and seeding messages into the collective psyche of the herd – through subversive or non-consensual methods. In doing so, their hearts and minds become impregnated with the desired ideas.

Eg. | sourcewatch.org

"Some scholars refer to propaganda as a 'hypodermic approach' to communication, in which the communicator's objective is to 'inject' his ideas into the minds of a 'target population.'... This is quite different from the democratic model, which views communications as a dialogue between presumed equals. The goal of the propaganda model is simply to achieve efficient indoctrination, and it therefore tends to regard the assumptions of the democratic model as inconvenient obstacles to efficient communication."

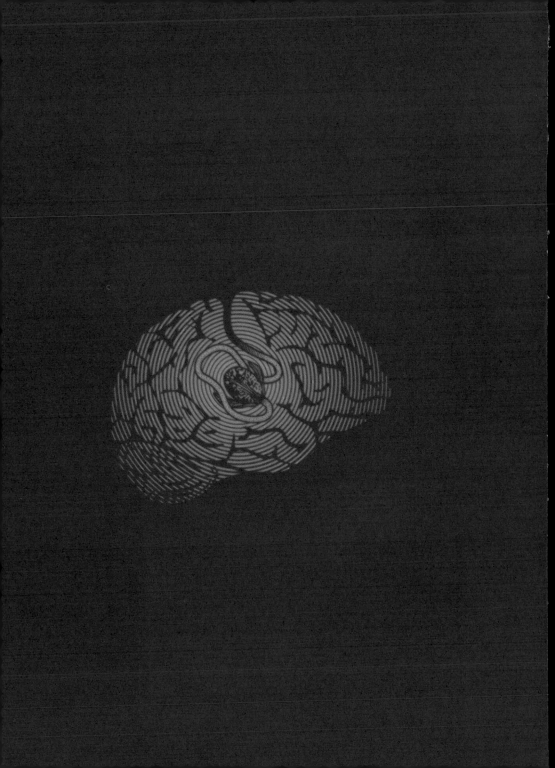

Germination

Once the seed has been planted, a period of incubation is required.

During this time, the idea will begin to lay it's roots deep into the *cows* psyche.

This is a delicate stage of the process, as in it's embryonic form the idea's survival is dependent on a hospitable environment.

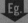 | **Rod Serling, 1924 – 1975**

"The tools of conquest do not necessarily come with bombs, and explosions, and fallout. There are weapons that are simply thoughts, ideas, prejudices, to be found only in the minds of men. For the record, prejudices can kill and suspicion can destroy. A thoughtless, frightened search for a scapegoat has a fallout all its own for the children yet unborn."

Thought farming

The seedling-thoughts which sprout up need to be nurtured until firmly established.

Conflicting ideas must be regularly purged of the environment until the desired thoughts have had a chance to mature. Once fully grown, these prejudice mind-sets are harvested – yielding the conformist and obedient behaviour which is the desired outcome of Spinfluence.

 simplypsychology.org/obedience

"Millions of people were killed in Nazi Germany in concentration camps but Hitler couldn't have killed them all, nor could a handful of people. What made all those people follow the orders they were given? Were they afraid, or was there something in their personality that made them like that? In order to obey authority, the obeying person has to accept that it is legitimate (i.e. rightful, legal) for the command to be made of them."

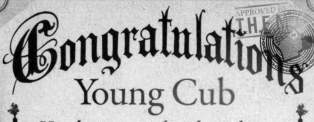

Congratulations

Young Cub

*You have completed reading
the 10 steps of:*

SPINFLUENCE

— THE —

HARDCORE PROPAGANDA MANUAL

FOR CONTROLLING THE MASSES

We trust you have found this manual enlightening whilst you have prepared to become a fully qualified Warden Of Language & Falsities. There is one last lesson to be learnt. You are now invited to open the sealed section on the following page. Read the final words with care and devour their meaning.

Only once you've looked *them* in the eye and absorbed the hidden truth within your heart, will we consider you worthy of becoming a *wolf*. Only then will we allow you to pledge your allegiance to Wolf&Co.

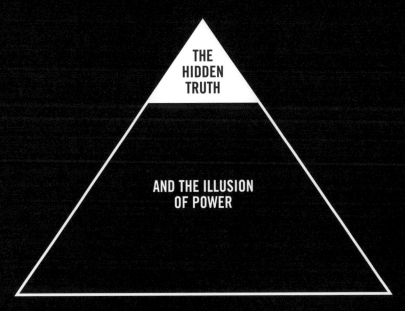

THE
HIDDEN
TRUTH

AND THE ILLUSION
OF POWER

The truth is known to hurt, and what follows may do so, as the moral of our story becomes painfully clear. It is important you understand that with the immense power you will shortly gain, comes great responsibility. It is now up to you Young Cub, to grasp the magnitude of why we serve *them*. Let the following be of warning:

T.H.E.Y. represent only 1% of the population, yet own the majority of wealth and are able to control the rest of society.

They do so by remaining hidden at all times, and understanding the power of Spinfluence.

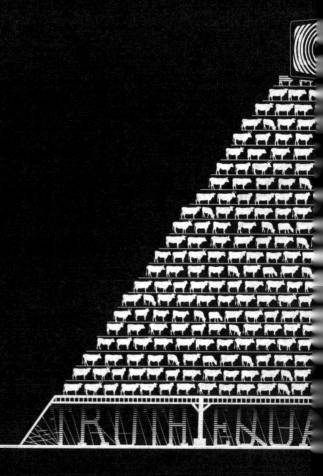

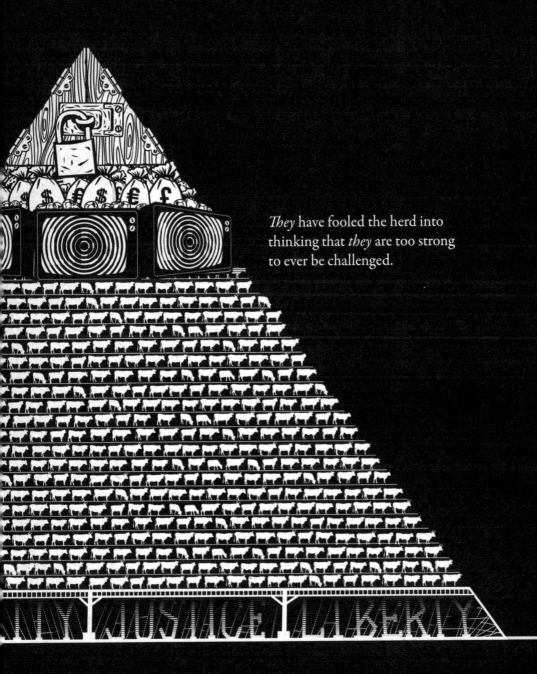

They have fooled the herd into thinking that *they* are too strong to ever be challenged.

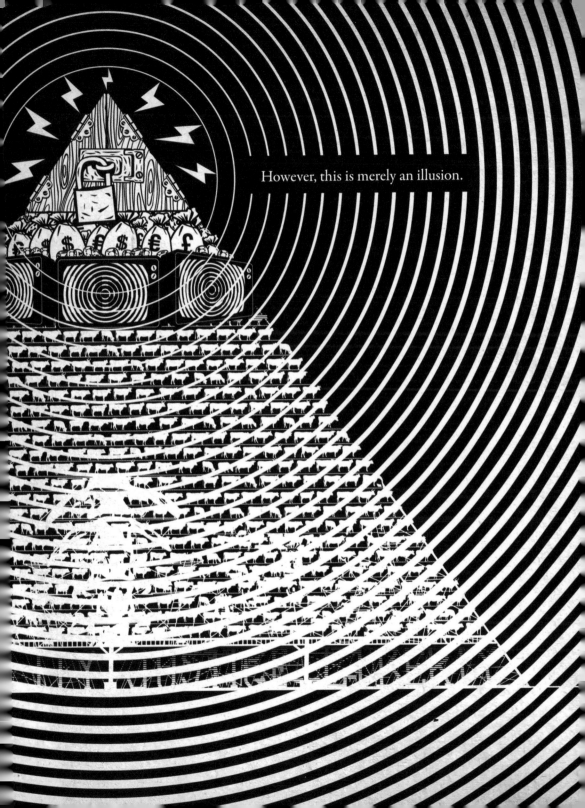

However, this is merely an illusion.

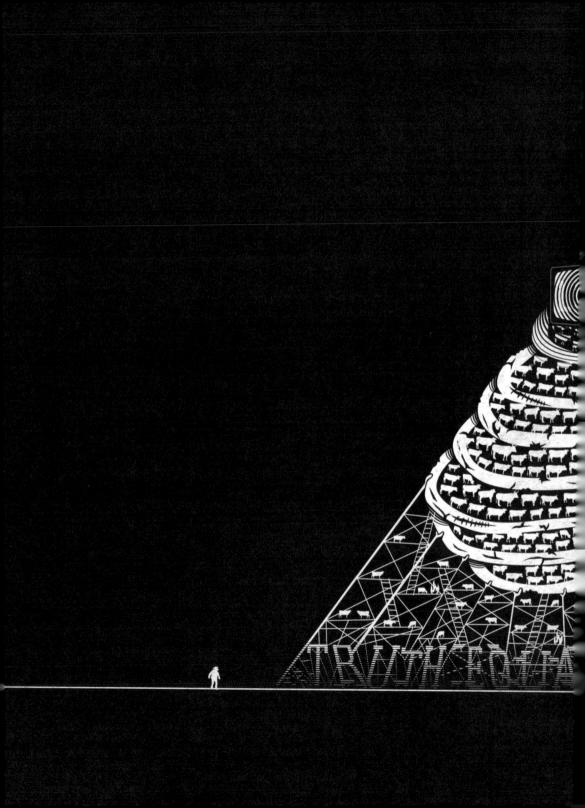

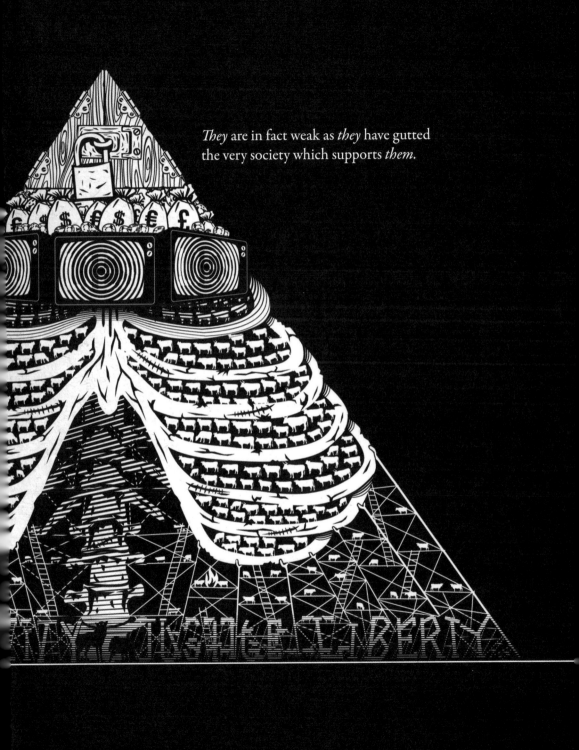

They are in fact weak as *they* have gutted
the very society which supports *them*.

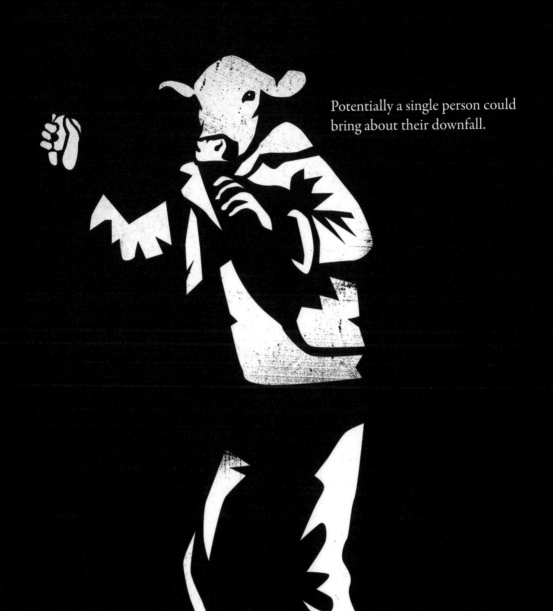

Potentially a single person could bring about their downfall.

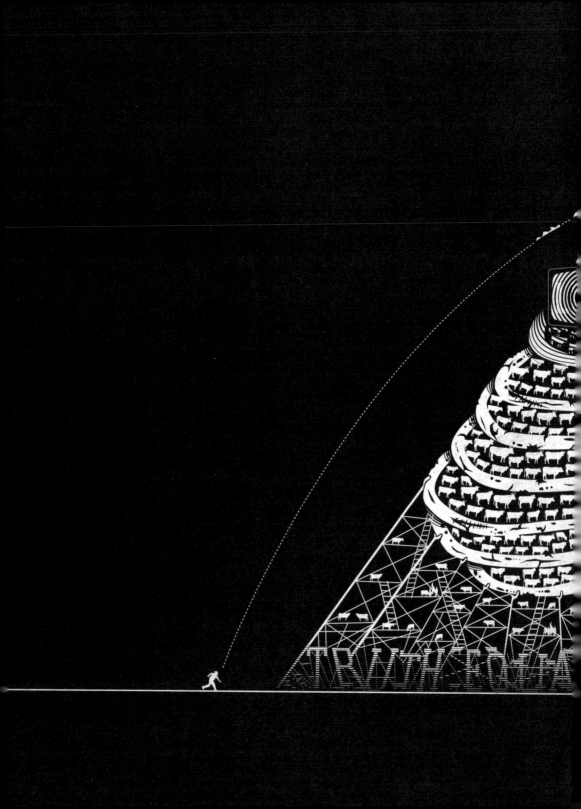

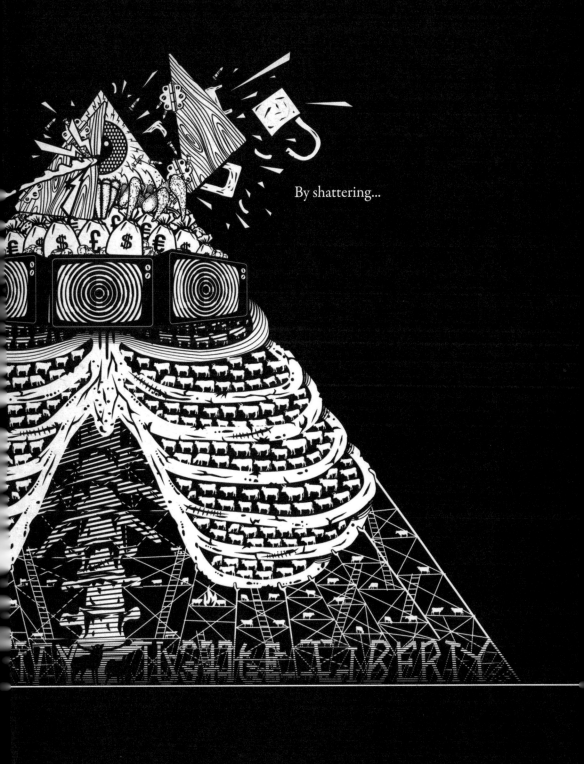

By shattering...

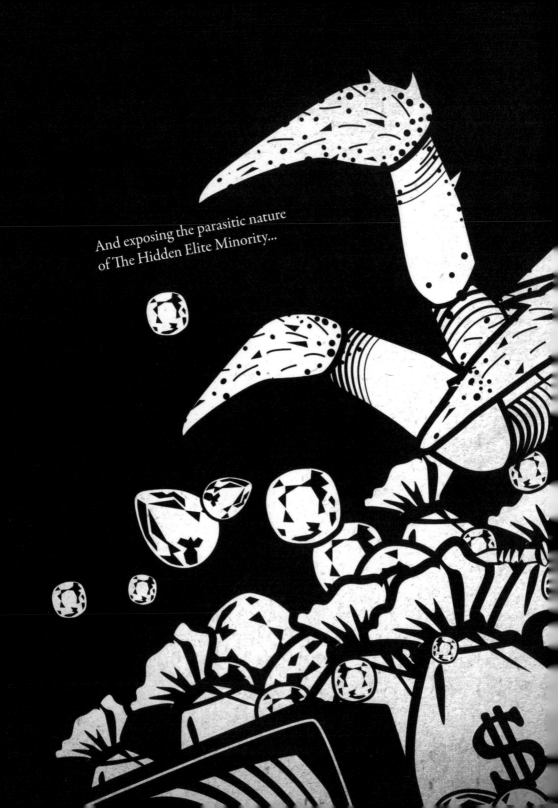

And exposing the parasitic nature
of The Hidden Elite Minority...

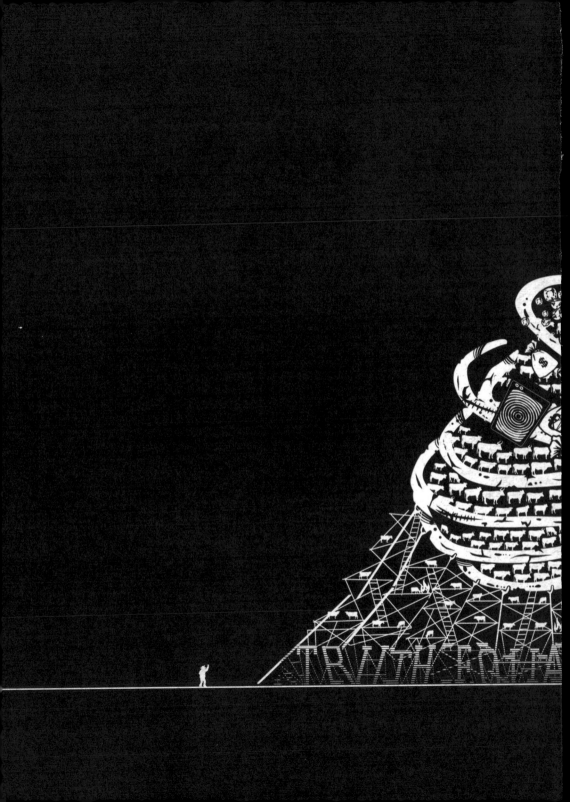

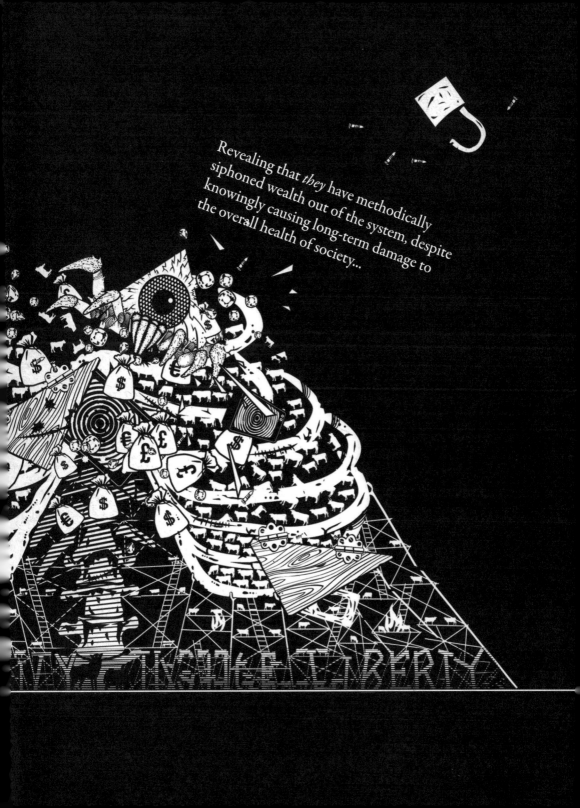

Revealing that *they* have methodically siphoned wealth out of the system, despite knowingly causing long-term damage to the overall health of society...

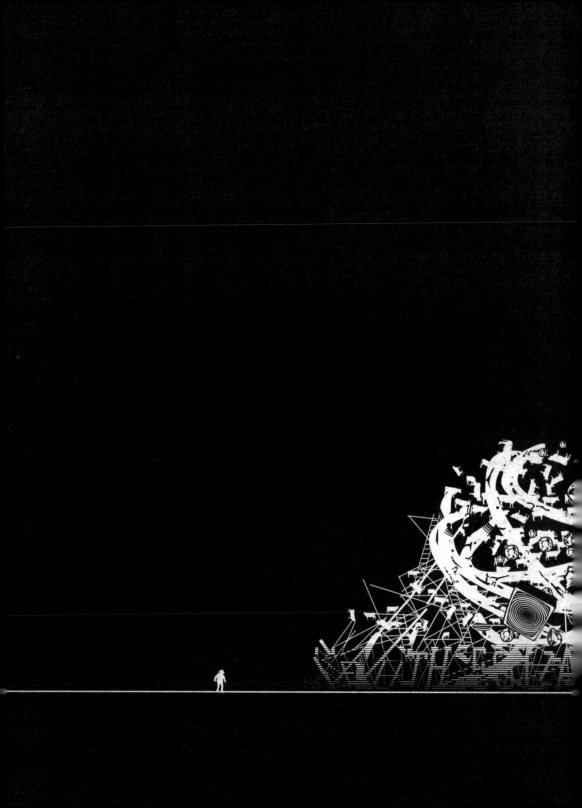

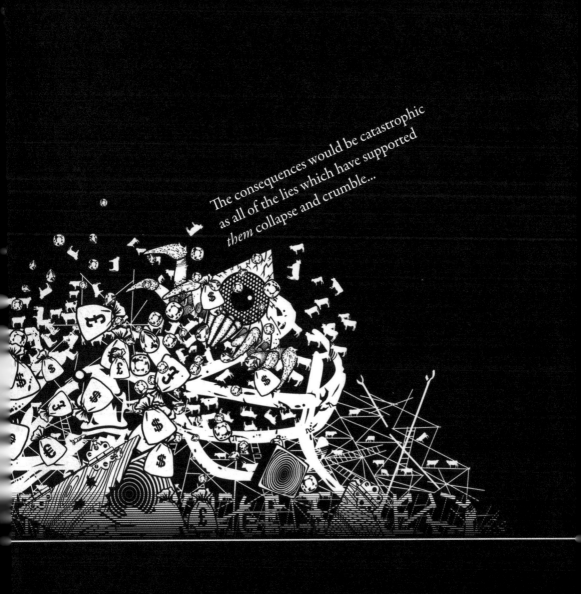

The consequences would be catastrophic as all of the lies which have supported *them* collapse and crumble...

It is only due to the excellent quality of Spinfluence that Wolf&Co. provide which allows *them* to remain in power and keeps the herd subservient.

Thus, ensuring that the scenario depicted here never eventuates...

Because the thing which
scares *them* the most...

Is someone who sees through the lies...

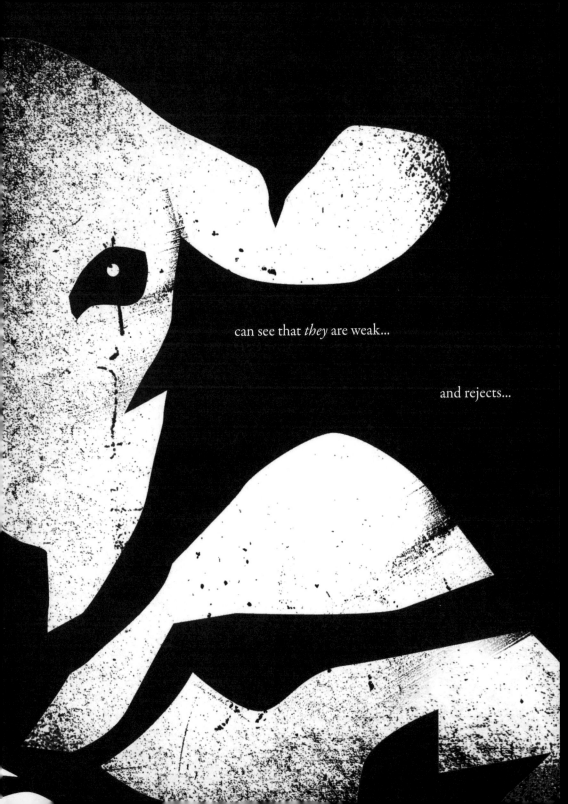

can see that *they* are weak...

and rejects...

Happiness

through conformity.

The Pledge of The W.O.L.F.

I, ▓▓▓▓▓▓▓▓▓▓▓▓▓▓▓▓▓▓▓▓▓▓▓▓▓

As a newly indoctrinated

WARDEN OF LANGUAGE & FALSITIES

of

🐄 Wolf&Co. PROPAGANDA AGENCY

● ● ●

Do hereby swear to honour and obey all of the teachings contained within this book of Spinfluence. I have read these final words of warning and understand the moral of the story. I understand the importance of hiding the truth from the herd and maintaining the illusion of power which protects *them*. I pledge my undying devotion to preserving the safety and security of The Hidden Elite Minority and in doing so howl to the moon above.

SIGNED: DATE: RIGHT THUMB

APPROVED BY T.H.E.M.

THANKS

If I've ever argued with you about the way the world works, then I extend both an apology and my thanks.

It is only through those who have challenged my views, that I've been able to put together a body of work that shines a light on the hypocrisy and corruption that underpins the world we find ourselves spectators – innocent or otherwise, within.

This has put me at odds with many people over the years. So to my loved ones who have put up with me, I am truly grateful.

Life's a bit like a puzzle. While we're here we have to try and solve whatever small part of it we can. Possibly even make sense of it. Charlotte, I know all of these late nights seem like madness, so thanks for helping keep to me grounded.

To those who lent a hand – Adrian Palengat, Hermione Pakenham, Tony Clewett, Rob Banks, Peter Vegas, Gary Shove. My humble gratitude is yours.

And Weiner. Thanks for the argument buddy, I owe you a beer.

ACKNOWLEDGEMENT

Wolf&Co. appreciate the following sources that have informed the writing of the following chapters:

Institute for Propaganda Analysis
Step 6. Spin: The techniques described here are based on the 'common techniques' identified by the IPA.

Edward S. Herman & Noam Chomsky
Step 8. Filters: The points described here are directly influenced by the concepts described in their book Manufacturing Consent: The Political Economy of the Mass Media.

THE AUTHOR

Nicholas McFarlane, born 1976, moved from New Zealand to London at the age of 25. This coincided with the Bush and Blair regime's "faulty intelligence" led invasion of Iraq.

Sickened from a daily diet of propaganda surrounding the state-sponsored violence, served up as tabloid entertainment, he began to develop the underlying theories of Spinfluence.

His writings caught the attention of *Wolf&Co.* where after a period of programming was shown the error of his ways and politely encouraged to write 'the manual' at the behest of the company.

However, he was later dishonourably discharged after it came to the attention of authorities that he'd been inserting subversive messages into his work, undermining the integrity of *Wolf&Co.*

He was deported back to New Zealand, where he was given a new identity and integrated back into society. He is now happily married with three children.

Photo: The Right Honourable Mike Braid

PLEASE KEEP IN TOUCH:

spinfluence.co.nz